Nichols' Lost Leicestershire

Stephen Butt

AMBERLEY

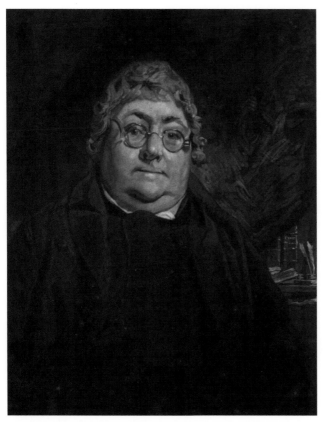

John Nichols. Portrait by John Jackson RA, engraved by Henry Meyer (1 July 1811).

First published 2014

Amberley Publishing
The Hill, Stroud
Gloucestershire, GL5 4EP

www.amberley-books.com

British Library Cataloguing in Publication Data.
A catalogue record for this book is available from the British Library.

ISBN 978 1 4456 2077 0 (print)
ISBN 978 1 4456 2082 4 (ebook)

Typesetting and Origination by Amberley Publishing.
Printed in Great Britain.

Contents

Introduction

The History and Antiquities of the County of Leicester by John Nichols is a remarkable work, and the greatest of all the English county histories of the eighteenth and nineteenth centuries.

To describe Nichols as the author of this work is to perhaps overlook the immensity of the task he set himself. He was the printer and the publisher, and the man who researched the many varied earlier sources from which he drew much of his material. Today, the various roles he undertook would involve an entire team. He also commissioned, encouraged, cajoled, persuaded and organised an army of engravers, illustrators, local historians and writers to travel to the most remote parishes in Leicestershire, in all winds and weathers, to provide the material he needed. He distributed questionnaires to rectors and churchwardens, carefully and diligently combining material from hundreds of sources and contributors, and then finally drew together this vast amount of material into one completed work in eight massive volumes.

To undertake a project of this scale in the twenty-first century, even with the technical benefits of mobile phones and the Internet, would be a major undertaking. Despite modern mapping and satellite navigation, this author can vouch for the fact that it is still possible to get lost in rural Leicestershire. It is also possible for the most modern of road vehicles to have punctures and to become embedded in soft Leicestershire clay. Nichols sometimes alludes to the difficult conditions, as in the opening paragraph to his section on Kirby Muxloe:

> The road which leads to the same branching off from the aforesaid turnpike near the third mile-stone, across some deep sands, to about halfway to Kirby, where the land from thence to Kirby appears a black and stiff clay. About the village appears the same stiff soil, which is frequently very disagreeable to both horse and rider; and where it is repaired is not much more agreeable, being a rough hard forest stone, without a covering of gravel.

Modern digital photography has some limitations compared with the techniques of Nichols' time. The artists who sketched the thousands of illustrations could compensate for a lack of light, although they also made use of shadows to enhance their work, allowing readers to judge the time of day that a particular sketch had been made. Photography is also limited by the type of lenses available, whereas the

eighteenth and nineteenth-century engravers could present a wider panoramic view at will, showing the physical relationship of church, manor and hall for instance. Perhaps surprisingly, the primary reason why it is not possible to recreate the exact perspectives of many of the engravings today is not by reason of intruding later development, but because of the number of tall trees that now grow in churchyards. Where trees appear in the views of churches in Nichols' book, they tend to be small, and the building therefore dominates the scene. This may of course be a technique adopted by some of the engravers. It may be that the illustrators provided several separate sketches of a particular church from all sides, which the engraver was later able to combine into one isometric view.

Although most of Nichols' engravers were seasoned travellers, some had only a limited knowledge of the topography of Leicestershire, and needed to reach their destinations by coach, on horseback and, sometimes, on foot. On some occasions, John Nichols and members of his family accompanied them. In some engravings, figures have been included in the foreground. Sometimes these are used to provide scale and perspective, but, as Julian Pooley of the Nichols Archive Project has demonstrated, in a number of instances these figures are of John Nichols and his family. At Thorpe Arnold and at Burton Lazars, for example, a small Nichols family group is portrayed, including the coach that has brought them to the particular location.

It is interesting to note that the majority of dates relating to when the engravings were undertaken are the late summer months, from July to October, when rainfall was less, and travel along the lanes of Leicestershire was easier.

Yet despite such practical difficulties, John Nichols saw his work through from conception to completion over a period of almost two decades, with only the technology of his age. Every one of the 5.5 million words was written out in longhand and then set by his skilled compositors, letter by letter on to more than 4,500 folio pages, many then being returned to their authors or to his contributors for editing, not once, but time and time again.

Year upon year, Nichols 'commuted' between his printing works in London and the subject of his great work, the county of Leicestershire. Travelling took time. The first mail coach conveyed post from London to Market Harborough in 1785, only ten years before John Nichols published the first volume of his Leicestershire history.

In 1811, the year in which Nichols published his volume on Sparkenhoe, the fastest journey time from London to a Leicestershire destination was thirteen hours, this being 89 miles from London to Lutterworth. This represented an average speed of just 6.84 mph. Yet Nichols made this journey on countless occasions. Travel on the mail coaches was nearly always at night when the roads were less busy and the coaches could travel faster, but at night, after the sun had set, the temperatures dropped.

By the time Nichols' final volume had been completed, George Stephenson had built his first steam locomotive. The rural agrarian county that Nichols described was beginning to feel the effects of the Industrial Revolution.

The first transport revolution was the turnpiking of the major routes across the county which began in Leicestershire in 1721/22. The road from Market Harborough to Loughborough via Leicester, now the A6, was the first to be turnpiked, initially from Leicester to Market Harborough and then from Leicester to Loughborough. The trust for these two turnpikes was set up in 1726, and by 1807, all the main Turnpike Trusts for the county were operating.

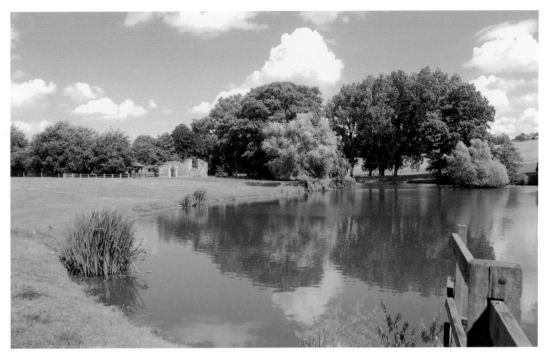

The ruined chapel of St Michael, Blaston, August 2014.

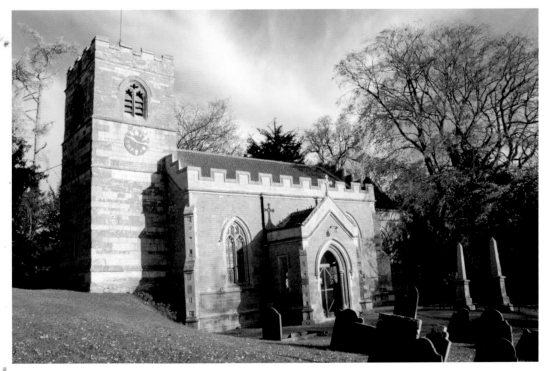

The church of St Michael and All Angels, Cranoe, April 2014.

However, many routes in Leicestershire were not turnpiked until the turn of the nineteenth century, including those between Melton Mowbray and Grantham, Leicester and Hinckley, and in north-west Leicestershire.

The period during which Nichols was creating his Leicestershire history was a time of much innovation. The new road building and surfacing techniques of John MacAdam and Thomas Telford were introduced around 1815. In 1808, Londoners could ride on Richard Trevithick's 'steam circus' hauled by his steam locomotive, *Catch Me Who Can*. George Stephenson constructed his first steam locomotive in 1814. The Leicester–Swannington railway line, engineered by Robert Stephenson, opened in 1832, only seventeen years after the completion of Nichols' Leicestershire work.

John Palmer, a theatre owner from Bath in Somerset, and the Post Office, first used stagecoaches for mail in 1782. On some routes this innovation halved the journey and delivery time for mail, compared with the earlier system of riders working in relays and passing the post from one to the other. However, stagecoaches did not reach all the principal towns and cities until 1797, by which time there were forty-two routes. The 'golden age' of the stagecoach is said to be the decades either side of the turn of the nineteenth century. The first mail coach passed through Harborough in the summer of 1785.

The old Roman routes, such as the Great North Road, were still important not only for travel but for the conveyance of news. These ancient paths were the information superhighways of the time. My ancestor, Robert Woodford, records in his diary for 1637–42 how he would ride out from his home in Northampton to Towcester to stay overnight at one of the several inns, specifically to overhear the news and gossip being exchanged between travellers from the north and the south. In the morning, he would return home to convey the news to his friends and neighbours.

Inevitably, there are many errors in Nichols' work. Documents with conflicting details stand side by side, often without critical analysis. Some pages and engravings are misplaced, dates of events cannot be relied upon, and the pagination is awry in places.

Despite, or because of, these issues, one of the many attractions of this work is the debate, discussion and argument it has provoked. For example, inside one East Goscote volume, the following note was found by this author:

> To prove that Robert Fitz Ranulf, Baron de Alfreton, did not found the abbey of Beauchief, 'as an expiation for the murder of Thomas Becket,' and that he was neither an accomplice, nor in any ways concerned, in that murder; see 'The historical account of Beauchief Abbey,' by S.Pegge, printed A.D. 1801, Chap. II, pages 11–37. W.L.

Coincidentally, Samuel Pegge was well known to Nichols as a prolific contributor to *The Gentleman's Magazine*, which Nichols edited and printed. Pegge often wrote under the pseudonym of Paul Gamesegge, and Nichols also wrote letters and articles for his own journal using many different names, sometimes to check facts that would be compiled into his history. So it is important to accept this immense work for what it is, a rich compendium of information, and to then use Nichols' signposting to verify the facts and the context.

We each have our own reasons for consulting Nichols. I am descended from the Woodford family of Leicester and Leicestershire, and in his commentaries on the manors held by my family, Nichols reproduces extensive extracts from the family's cartulary.

Leicestershire historians George Farnham and A. Hamilton-Thompson were very critical of Nichols' work, as far as the scope of this comment regarding the pedigree of the Leicestershire Woodford family is concerned:

> A foolish mistake of Nichols, taken from the Dodsworth MSS and also apparently from the compiler of that curious collection called the Woodford Cartulary. Such an error, whilst it illustrates the singularly uncritical habit of Nichols mind, does not increase one's belief in the accuracy either of the Woodford Cartulary or of the Dodsworth MSS. Nichols is hopelessly inaccurate in his early pedigrees because he trusted to the stories of such compilations as the Woodford Cartulary and to other abstractors' documents instead of going to the original and making abstracts of his own.

This seems to be somewhat unfair criticism. Nichols valued and respected the manuscripts he had obtained, and sought to reproduce them in the form in which he received them. He did not compose the early pedigrees, but presented them to his readers, many of whom, as subscribers, he knew personally. In the case of the Woodford family he printed two conflicting pedigrees on the same page, not in error but no doubt to allow the reader to compare and to interpret.

Robert Rutland commented in his paper to the Leicestershire Archaeological and Historical Society on *Leicestershire Archaeology to 1849*: 'Nichols was not giving an independent appraisal, but reporting the current interpretations of the various antiquities he mentions.'

Although many churches have been refurbished and a significant number of Leicestershire's country houses have been demolished, in some ways it is interesting to see how little has changed in the 200 years since Nichols' engravers set to work. In many churchyards, such as at Foxton and Burton Lazars, memorial headstones which appear in the engravings are still to be found in the same location. The same species of trees are growing in the churchyards. At Wyfordby and Sproxton, worshippers can hear the same bells that were heard by Nichols and his friends.

As the television historian Michael Wood commented on this unique contribution to the history of Leicestershire in his Leicestershire-based *Story of England* BBC series:

> It has many errors of course, but its vast assemblage of material, though uneven in its scholarship by today's standards, was an indispensable tool for the searcher after the history of Middle England. He (John Nichols) taught them, and us, where, and how, to look.

It would be a great disservice to suggest that this book of very modest proportions could reflect adequately the greatness of John Nichols' work. Constraints of space have meant that from over 5,000 engravings, this book contains a representative sample of around 100, and cannot reflect the wealth of armorial illustrations and engravings of monuments, memorials and portraits which add so much to the original work.

Geologists also benefit from Nichols' work. He gave us one of the very earliest (perhaps the oldest) scientific descriptions and figure of a plesiosaur fossil, and an illustrated list of fossils prepared by the poet George Crabbe while he was curate in Stathern after serving as chaplain to the Duke of Rutland at Belvoir Castle.

This book is offered as a celebration of the greatest of the antiquarian county histories, and as a way of encouraging all who may be interested in the history of Leicestershire to explore further this monumental work.

John Nichols laid out his eight volumes on the basis of the hundreds of the county together with the town of Leicester. This book follows the same structure.

A hundred, when introduced by the Saxons, was an area of land that sustained around 100 households. Within each hundred was a meeting place where the leaders discussed local issues, and trials were held. The name of the hundred was normally that of its meeting place.

In the area of the Danelaw, the lands in the east and East Midlands occupied by the Danes following AD 800, the approximate equivalent land divisions were called *wapentakes*. The origin of this word may be Old Norse from a show or ownership of weapons as the right to represent one's community or local area.

By the time of the Domesday Book, Leicestershire had four *wapentakes*: Gartree, Framland, Goscote and Guthlaxton. East Goscote, West Goscote and Sparkenhoe were created by the division of the former Goscote in 1346, making the six hundreds as in Nichols. Each name derives from the location where an annual meeting would take place, usually dictated by the topography of the land. Where the Roman *via devana*, which linked Leicester to Medbourne, and possibly Godmanchester (in modern Cambridgeshire), crossed a Bronze Age trackway, is a piece of land on which grew the Gartree Oak. It was here that the court of the Gartree Hundred met until 1750 when it moved to the Bull's Head in Tur Langton – the nearest inn.

In 2014, Gartree survives as an electoral division of Leicestershire County Council. The present elected member for the Gartree ward lives less than 3 miles from the site of the Gartree Oak.

The Engravers and Artists

The names of the men who provided the thousands of engravings for *The History and Antiquities of the County of Leicester* are printed next to most of the plates for which they were responsible.

Without exception they were remarkable people, not only being talented artists but also seasoned travellers, antiquarians and historians. One was born in Philadelphia, USA, and another in Switzerland. Some were occupied in high-profile architectural work, one became John Nichols' son-in-law and, sadly, more than one died in poverty. Most were known to Nichols through his London connections with engravers, artists, printers and antiquaries. In the case of the Longmate family, both father and son worked on the Leicestershire history. Barak Longmate Snr died in 1793, two years before the first of the volumes was published.

Over the quarter of a century that Nichols worked on his Leicestershire history, some members of his small army of illustrators fell on hard times, suffered close personal losses, and even found themselves in debtors' prisons. Documents show that Nichols cared for them as a father figure, maintaining them and mindful of their financial circumstances. Nevertheless, despite his help, some died in poor and even tragic circumstances.

Alexander Bannerman (*c.* 1730–89)

Alexander Bannerman was born in Cambridge around 1730, and was living in the town in 1770. Very little is known of his youth, training or business activities. By 1766, he was a member of the Incorporated Society of Artists, and lists of his works indicate a preference for portraiture rather than architecture or landscape.

James Basire (Snr) (1730–1802)

James Basire came from a family of engravers, and is regarded as the most successful and significant of four generations who worked in this field. His father, Isaac Basire (1704–68), was a cartographer, and his son (1769–1822) and grandson (1796–1869) were both named James and were successful and accomplished engravers in their own rights. They all lived comparably long lives and therefore their careers overlapped, which has led to some difficulties in attributing their work.

Basire was a member of the Society of Antiquaries and specialised in prints depicting architecture. He worked from his London studio on Great Queen Street, between Holborn and Covent Garden. All three generations of his family were to be appointed in turn to the society.

Works by Basire can be seen in museums and galleries around the world, including the Fine Arts Museum in San Francisco, the Museum of Fine Arts in Boston, Christchurch Art Gallery in New Zealand, the National Library of Australia in Canberra, and the National Portrait Gallery in London.

In 1772, the English painter, poet and printmaker, William Blake, was apprenticed to Basire for seven years. There is no record of any serious disagreement or conflict between them, but Peter Ackroyd's biography of Blake records that the artist later added Basire's name to a list of artistic adversaries and then crossed it out.

Edward Blore (1787–1879)

Edward Blore was born in Derby. He was the son of the antiquarian writer Thomas Blore who wrote a number of histories about the East Midlands, including *The History and Antiquities of the County of Rutland,* which Edward illustrated. Blore had no formal training in architecture – his background being an antiquarian draughtsman. It is thought that he was apprenticed at some time to an engraver who had possibly worked for his father. He was elected Fellow of the Royal Society in 1841. He worked on the drawings of York and Peterborough for John Britton's *English Cathedrals,* and produced many architectural engravings for various county histories. In 1823, he toured northern England to make drawings for a work called the *Monumental Remains of Noble and Eminent Persons,* issued in several volumes with text by the Revd Philip Bliss, and completed in 1826. Blore engraved many of the plates himself.

Blore was appointed surveyor to Westminster Abbey in 1826, and in the following year was hired to provide plans for the chancel fittings of Peterborough Cathedral. Shortly afterwards, he was employed to restore Lambeth Palace, which at that time was in a ruinous state. His work at Lambeth included the construction of a fire-proof room for the preservation of manuscripts and archives.

Blore is most well known for his completion of John Nash's design of Buckingham Palace after Nash had been dismissed, after the death of George IV in 1830. He agreed to the financial restraints that were imposed, and completed the building in a style similar to, but in a plainer style, than that proposed by Nash. In 1847, he returned to design the great façade facing the Mall and enclosing the central quadrangle. He also worked on St James' Palace in London, and on many other designs in both England and Scotland, including restoring the Salisbury Tower at Windsor Castle.

Blore was a personal friend of Sir Walter Scott, and like Scott, was interested in the baronial architecture of Scottish castles. From this relationship came a proposal from Prince Mikhail Semyonovich Vorontsov of the Crimea (now Ukraine) to design his grand and expansive palace in Alupka, which was constructed between 1828 and 1846 in a mixture of styles ranging from Gothic Revival to Moorish Revival. The palace's guidebook describes the building as 'Blore's tribute to Muslim architecture'. He died in London on 4 September 1879, and was buried in London's Highgate Cemetery.

John Cary (*c.* 1754–1835)

John Cary set up his own business in the Strand in 1783, having been apprenticed to an engraver. He gained a reputation for his globes and maps. His atlas, *The New and Correct English Atlas* published in 1787, became the standard reference work in England. His published atlases included *New British Atlas* (1805) with John Stockdale, *Cary's New Universal Atlas* (1808), *Cary's English Atlas* (1809) and his *New Elementary Atlas* (1813).

In 1794, Cary was commissioned by the Postmaster General to survey England's roads. The result of this complex project was *Cary's New Itinerary* (1798) – a map of all the major roads in England and Wales.

Barak Longmate Snr (1738–93)
Barak Longmate the Younger (1768–1836)

Barak Longmate was key to the successful completion of the *History and Antiquities of the County of Leicester*. He was a long-standing friend and assistant to Nichols, and shared his interest in antiquarian subjects.

Longmate succeeded his father in his profession and also as the editor of the *Pocket Peerage of Great Britain and Ireland*, of which he issued an edition in two duodecimo volumes in 1813.

He was a fine draughtsman and well-skilled in heraldry, and so was of much assistance to Nichols and other antiquarians in their topographical work. In 1801, he made notes on the churches in Gloucestershire parishes, with a view to publishing a continuation of Ralph Bigland's history of that county. The disastrous fire at Nichols' printing works in 1808 caused the abandonment of the work.

Longmate Snr died in 1793 in Noel Street, Soho, and was buried in Marylebone churchyard. According to dates on engravings, his son was working on Nichols' Leicestershire in the summer of that year, only months after his father had died. At that time, Longmate (Jnr) was twenty-six years old. His father was also a genealogist and heraldic engraver of renown. He engraved some topographical drawings, but was more recognised as a heraldic engraver.

A manuscript account book kept by John Nichols, now in the archives of the British Art Centre of Yale University, provides details of payments made by Nichols to Longmate, and the amount of work that the engraver completed between 1807 and 1816. The accounts are in pen and brown ink throughout, probably in a single hand, and on paper of varying sizes.

One account of 1811 is recorded on paper with an engraved letterhead reading: 'To B. Longmate, engraver in its various branches.' Also present are small slips of paper bearing Longmate's signed receipt of payment. Attached to the front endpapers is an engraved silhouette portrait of John Nichols.

The accounts record over 300 pieces of engraving work by Longmate, for which Nichols paid around £325. The single most expensive piece appears to be plate 98 of volume four of the Leicester history, in which Longmate engraved four monuments, sixteen small coats of arms, and twelve large coats of arms at a cost of £9 18s.

The document provides a chronological record of Longmate's work for Nichols. The varied work includes the engraving of portraits, views, plans, and many coats of arms,

as well as engraved writing, 'pipe writing', and 'paging'. Longmate is also credited for reworking engravings, here described as 'taking out', 'cleaning', and 'alteration'. For each service, the date, activity, and costs are recorded.

Nichols does not explicitly record the publications for which Longmate's engravings were commissioned. From 1807 to 1811, his work was in part, or perhaps entirely, for inclusion in volume four published in two parts in 1810/11.

Longmate went on to provide engravings of Dorset for John Hutchins' *History and Antiquities of Sherbourne in the County of Dorset*, published by Nichols in 1815.

James Peller Malcolm (1767–1815)

James Malcolm was born in Philadelphia, USA, in August 1767. He was sent to a local Quaker school, but his family were forced to move to Pennsylvania to escape the fighting in the American War of Independence. They returned in 1784 when the hostilities had ceased.

Malcolm moved to London to attend the Royal Academy, where he studied for two years. He then began engraving and compiling books on topographical and historical subjects, having discovered that historical and landscape painting were not profitable. He was later elected a Fellow of the Society of Antiquaries.

Malcolm engraved two of the three notable views of Leicester Abbey in Vol. I Part II of Nichols' history, in 1794 and 1796.

Malcolm provided many engravings for Nichols' other publications including *The Gentleman's Magazine* and his *Excursions through Kent*. His most celebrated work is *Londinium Redivivum, or an Antient History and Modern Description of London, compiled from Parochial Records, Archives of various Foundations*, published in four volumes between 1802 and 1807.

Malcom died in Gee Street, Clarendon Square, London, on 5 April 1815, virtually penniless – leaving his mother and wife without provision.

Thomas Prattent (*fl.* 1790–1819)

Thomas Prattent was a draughtsman, engraver, printer and printseller based in London. He was a descendant of a family from Bristol. His premises were in the Cloth Fair in West Smithfield. He achieved recognition as an architectural engraver, producing many attractive views of London and the surrounding boroughs. As well as detailed architectural work, he was known for very delicate portraiture. The Victoria and Albert Museum holds five of his original engravings. He also provided wood cuts for *The Gentleman's Magazine* between 1787 and 1817, and engravings of plants for Nicholas Culpepper's *English Physician and Complete Herbal* (1708 and 1805).

A coloured engraving titled *Almeida, Portrait of Fashionable Lady in Countryside*, completed in 1787, was offered for sale in 2014 for $600.

Prattent and his wife, Elizabeth, had one son, also named Thomas, who was born in 1830.

John Pridden (1758–1825)

John Pridden was a priest as well as an antiquary. He was the eldest son of a London bookseller. His education began at St Paul's School in London in 1764, and continued at Queen's College, Oxford, from where he graduated with a BA degree in 1781. He then undertook training for the ministry at St John's College, Cambridge, where he gained his MA and was ordained. His clerical work included numerous appointments, such as that of a minor canon of St Paul's Cathedral, curate of St Bride's, Fleet Street, priest in ordinary of His Majesty's Chapel Royal and a minor canon of Westminster Abbey. He was vicar of Caddington, Bedfordshire, from 1797, and finally rector of the united parishes of St George, Botolph Lane, and St Botolph, Bishopsgate.

It is surprising that he was able to devote time to engraving and to work so closely with Nichols. He married Anne, Nichols' daughter, and the trio appear in several engravings. His architectural work resulted in some surprising activities, including a design for the sea-bathing infirmary at Margate of which he was joint founder. He was elected Fellow of the Society of Antiquaries of London in 1785.

Pridden died on 5 April 1825 at his house in Fleet Street, and was buried on 12 April at St Mary's, Islington, beside his first wife.

Jacob Schnebbelie (1760–92)

The Schnebbelie family came from Switzerland, but Jacob was born in Duke's Court, St Martin's Lane, London, in August 1760, and became known as a truly English draughtsman who specialised in monuments and other historical subjects. His father had served in the Dutch Army at Bergen-op-Zoom before settling in England, becoming a confectioner in Rochester, Kent.

Jacob was also a confectioner in the early years of his working life – first in Canterbury and then in Hammersmith. Although having no formal training, he became a drawingmaster at Westminster and other schools.

Schnebbelie was later appointed draughtsman to the Society of Antiquaries of London through the influence of the president, Lord Leicester. The majority of the views of ancient buildings published in the second and third volumes of *Vetusta Monumenta* were drawn by him. He also made many of the drawings for Gough's *Sepulchral Monuments of Great Britain*.

In 1788, he published a set of four views of St Albans, drawn and etched by himself and aquatinted by Jukes. In 1791, he undertook the publication of the *Antiquaries' Museum*, illustrating the ancient architecture, painting, and sculpture of Great Britain in a series of plates etched and aquatinted by himself. However, he lived to complete only three parts. The work was continued by his friends, Richard Gough and John Nichols, and was issued as a volume with a memoir of him in 1800.

After an illness of six weeks, Schnebbelie died at his home in Poland Street, London, on 21 February 1792, leaving a widow and three children. It is said that his illness, which began with rheumatic fever, was caused by working too hard. Two sons and a daughter died during the last year of their father's life, and a son was born five days after his death.

Revd Stebbing Shaw (1762–1802)

Revd Stebbing Shaw was born near Stone in Staffordshire. He owned a small estate in Staffordshire, which passed to his son. He was educated at Repton School, and in 1780, was admitted as pensioner at Queens' College, Cambridge. He graduated in 1784 (BA), 1787 (MA) and 1796 (BD); was elected scholar in 1784 and fellow in 1786, after which he took orders in the English church.

Around 1785, Shaw went to live at the house of Sir Robert Burdett in Ealing as tutor to his son, the future Sir Francis Burdett. In the autumn of 1787, both tutor and pupil made a tour from London to the Highlands of Scotland. Shaw kept a private diary of their proceedings, which he published anonymously in 1788. He made a further tour to the West of England in 1788, and published an account of his travels the following year. On this occasion, he had studied the history of the places that he purposed visiting, and had made a careful investigation into the working of the mines in Cornwall. The book became popular, and was reprinted in Pinkerton's *Voyages* and in Mavor's *British Tourists* in 1789 and 1809.

Shaw moved to his father's rectory at Hartshorn in the summer of 1791, and conceived the idea of compiling the history of his native county of Staffordshire. The first volume of the *History and Antiquities of Staffordshire* was published in 1798, and the first part of the second volume in 1801. It included many of his own illustrations, some of which had already appeared in *The Gentleman's Magazine*. Only a few pages of the second volume were printed, and many unpublished plates are at the Salt Library in Stafford and the British Museum.

Shaw was elected Fellow of the Society of Antiquaries in 1795, and in 1799 he succeeded his father as rector of Hartshorn. At the beginning of 1801, he offered his services in examining the topographical and genealogical manuscripts at the British Museum. His early death the following year was apparently a happy release, as he is said to have died insane, due to overwork.

John Swaine (1775–1860)

John Swaine was born in Middlesex on 26 June 1775, the son of John and Margaret Swaine. He became a pupil of Jacob Schnebbelie and, later, of Barak Longmate. He is best known for his fine facsimile copies of old prints. He also engraved many illustrations for various scientific, topographical, and antiquarian works, and many subjects of natural history. He contributed engravings to *The Gentleman's Magazine* for fifty years from 1804.

Swaine married the daughter of his tutor, Barak Longmate, in 1797. She died in October 1822. Their only son, John Barak Swaine, studied at the school of the Royal Academy and, while still a boy, produced some fine antiquarian work. He died young in 1838, at the age of twenty-three years after a long illness.

Liparoti

Liparoti is possibly the engraver who is listed as living in Grosvenor Row, Chelsea, in August 1798. He engraved the illustration of Loddington in the volume on East Goscote, and a view of Shenstone from the Lichfield Road for Revd S. Shaw's *Staffordshire*.

John Walker (*fl.* 1795)

John Walker, Alexander Walker and Charles Walker were known jointly as J. & C. Walker, and were active between 1820 and 1895 as engravers, draughtsmen and publishers. They had several offices in Bernard Street, Russell Square (1830–36), Burleigh Street, The Strand (1837–40) and Castle Street, Holborn (1841–75).

The firm is best known for its work on the maps issued by the Society for the Diffusion of Useful Knowledge (SDUK). They also engraved a large amount of work for the British Admiralty, and issued several important maps of India and multiple issues of the *Royal Atlas*.

The Town of Leicester

Turning the pages of John Nichols' volume on the town of Leicester allows the historian to remove the clutter of the Victorian and Modern eras, and to see the key buildings of the old town without the distraction of the later periods.

It has been said that Leicester hides its long history well, and it has been only the incentive of the potentially rich rewards of heritage tourism in the twenty-first century that prompted the city to begin, at last, to value its past. Pevsner, in a rare mood of enthusiasm, commented in 1960 that: 'The group of Castle, St Mary, the Newarke, St Nicholas, the Roman Baths and the Guildhall is something the patriotic citizen of Leicester might proudly take any visitor to, British or foreign.' However, the town planner of that time, W. Conrad Smilgelski, failed to take heed, and chose instead to separate this historic group of buildings from the rest of the city with a central ring road, the consequences of which are only now, more than fifty years later, being addressed.

All Saints' Church

Situated outside of this historic group, the church of All Saints' stands with its west end bordering the ancient Highcross Street – the former principal thoroughfare of the ancient parish. Indeed, the length of the church on the south side is almost 5 feet less than the north side because the building, aligned to the east, respects the line of the ancient street. As this was also the main route from north to south through the town, and the location of significant public buildings and high status residences, All Saints' was at the centre of town life for many centuries. It is now in the shadow of a John Lewis department store and a cinema complex, and although no longer used for regular worship, it is, in a sense, returning to the heart of the commercial life of modern Leicester.

The view in Nichols is of the south side of the church from the opposite side of Highcross Street. The fascinating clock with two figures striking the hour probably dates to around 1620, and is not visible in the engraving because it was formerly fixed above the west door.

In the distance, engraver James Malcolm has included the tower of St Margaret's church (*right*) and the Cross Keys Inn (*left*). Architecturally, All Saints' has a complex history which possibly began as a cruciform building of Norman origin. The tower, now offset from the main space of the church, may originally have been centrally placed.

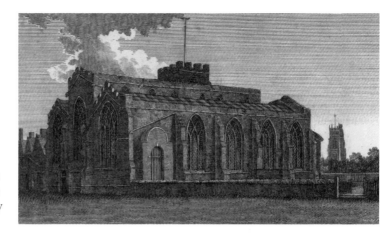

All Saints' church, Highcross Street, with St Margaret's church in the background, engraved by James Peller Malcolm.

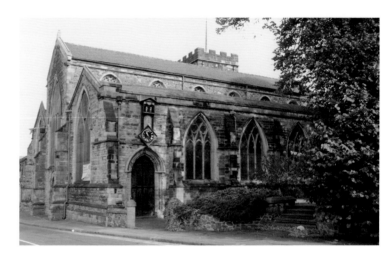

All Saints' church. The clock was restored in 1899 and again in 2009. The original jacks (the striking figures) were stolen in the 1970s.

The Blue Boar Inn

The role of this famous inn in the history of England has become known to a much wider community since the discovery of the remains of Richard III in the nearby precincts of the Greyfriars. Although the choir of the Greyfriars church was to be his resting place for over 500 years, the place where the monarch last rested in his lifetime was this inn on Highcross Street.

At that time, the Blue Boar was regarded as a modern and spacious establishment literally 'fit for a king', although it is said the king brought his own bed with him for the night of 20 August 1485. On previous visits to Leicester, he had stayed at the castle, but by this time, that building was falling into disrepair.

The Blue Boar was originally constructed in the mid-fifteenth century and was said to have been the most decorative of Leicester's residences of that period. It was demolished in March 1836. A new hostelry with the same name was constructed some 200 yards away on Southgate Street – the continuation of Highcross Street. The site of the original building is now, ironically, a Travelodge.

The Blue Boar Inn. Engraving by John Flower (1826).

Leicester Castle

The external appearance of Leicester Castle appears to have changed little in the past two centuries, but it hardly suggests that it is, as James Thompson described it in his paper to the Leicestershire Archaeological and Historical Society in 1856, 'probably the oldest and the only pure example existing in England of the Hall of a Norman Baron', or, as Prof. Walter Horn stated, 'the oldest surviving aisled and bay-divided hall of Europe' and 'the earliest residential timber-roof of Europe'.

Thompson wrote in a somewhat romantic style and allowed his imagination to influence his objectivity. But his work as a nineteenth-century antiquarian, following in the wake of Nichols, provides a valuable insight into the approach to Leicester's antiquities of that time. Certainly the message in the closing paragraph of his paper stills stands:

> The Hall of Leicester Castle is, then, a national monument, and belongs to all time. We received it as a heritage from our fathers; we should tend reverently what remains of it in our own day; let it afterwards tell to other times and other peoples, however imperfectly, the tradition it has told us not ingloriously.

To understand how the original motte and bailey construction related to its position, it is necessary to approach Leicester by way of the River Soar. It is then that its prominent location can be appreciated. The layout comprises of an Inner Bailey and Outer Bailey to the north, extended later to the south, and to the west, the mound of the original keep. Behind those defences are the castle's church of St Mary and the gateways into the town and to the Newarke.

Today, as in the time of Nichols, Castle Yard (that space of green between the Castle and the church of St Mary de Castro) is an oasis of peace, although it has also been a place of executions.

Leicester Castle from St Mary de Castro (October 2014).

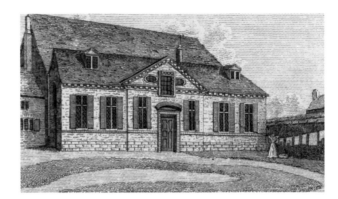

Leicester Castle engraved in 1796 by Barak Longmate. Note the washing being hung out to dry.

St Mary de Castro Church

The church has a long and fascinating history, which is inextricably linked with that of the castle, and therefore of the men and the monarchs who ruled Leicester and the country.

The church was founded in 1107 as a collegiate church, served by twelve canons and a dean. Legend suggests that the writer Geoffrey Chaucer married Philppa de Roet here. Henry VI was knighted here in 1426 when still a young child, while the famous Parliament of Bats was being held next door in the castle.

In 2014, the spire of St Mary de Castro, which had been a landmark in the landscape of Leicester for many centuries, was removed because its structural integrity was failing. It had dominated the surroundings. It was rebuilt in 1783, and repaired in the Victorian period, so the engravings in Nichols have a real value and significance.

The appeal to reconstruct the spire includes many imaginative and creative projects including the sale of a special brand of marmalade. Continuing its long history, the church of St Mary de Castro became the first in the country to be included in the Street View facility on Google, having been filmed by them in 2012.

The Newarke Gateway

The architectural dignity of the Newarke gateway, which was clearly designed to impress, was mislaid by Leicester's town planners for some years, who chose to isolate it from the rest of the world by a road system.

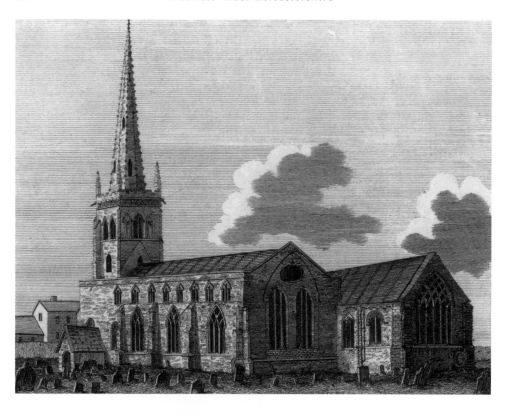

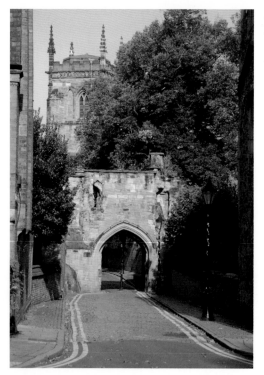

Above: St Mary de Castro by
Barak Longmate.

Left: St Mary de Castro photographed in
2014, viewed from The Newarke.

Even Barak Longmate in his engravings chose to present a romantic view instead of an architectural projection, although by including the slender spire of St Mary de Castro he succeeded in giving a sense of its dominance over the buildings that surrounded it until the late Victorian period. Longmate shows the gateway still serving its purpose as the entrance to the Newarke.

Since Nichols' time, the building has been surrounded by a multiplicity of activity and later construction. In 1894, it was extended to incorporate a drill hall. Later, it was used as a museum of the Leicestershire Regiment. Within its shadow, in the twentieth century, Midland Red built a bus station on part of the site of the ancient Church of St Mary of the Annunciation.

The imagination of De Montfort University, which has inherited much of the former Newarke, has returned some dignity to the gateway by landscaping the area within the former Newarke boundary. Leicester City Council has worked to realign the central ring road so that this ancient building is no longer isolated. Whether the university's new Hugh Aston Building, named after a former director of music of the college of the Newarke, complements or competes with the gateway, is a matter for debate.

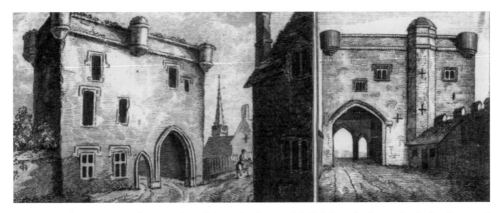

The Newarke Gateway. The view from Newarke Street with St Mary de Castro in the background (*left*) and from inside The Newarke (*right*).

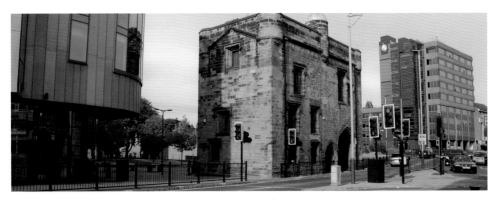

The Newarke Gateway is now flanked by De Montfort University's Hugh Aston Building (*left*) and Edith Murphy Building (*right*).

The Borough and County Gaols

The history of the two gaols that stood facing Highcross Street is long and complex, and at times, their maintenance was a drain on the finances of the town.

The Borough Gaol was most likely the earlier of the two buildings, and was probably in existence by the end of the thirteenth century. Around 1614, a new gaol was built on the site of the former St John's Hospital at the corner of Highcross Street and Causeway Lane, and this was demolished in 1792, revealing the ruins of the old hospital.

Nichols provides a valuable record of this event with detailed measurements of the remains undertaken by Throsby, who wrote a full description of them. They included an arch, which Throsby described as Saxon, several pillars and parts of walls. The nave was 17 feet 4 inches in width and 41 feet in length. Four large oak beams had been laid on the capitals of the pillars to support the floor when it was converted into a prison. Throsby suggested that these had been used originally to support the roof of the old church.

Another new gaol was erected in 1793 by John Johnson, which remained until 1837 when it too was demolished.

The history of the county gaol is also complex. The first building was constructed in the early years of the fourteenth century near to the shire hall, also on Highcross Street. It was not until the eighteenth century that another gaol was built at the junction of Highcross Street and Freeschool Lane. This building was in such a state of disrepair and dilapidation by the eighteenth century that it was condemned by the prison reformer John Howard (1726–90), and as a result, a new prison was completed in 1790–92. The architect of the new building was George Moneypenny of Derby.

In the nineteenth century, the town corporation, looking to replace their gaol, purchased this building when the county gaol moved to the present Leicester prison site on Welford Road. Fifty years later, the prison commissioners announced its closure, and it was repurchased by the town and demolished.

John Flower's view of Highcross Street includes Moneypenny's Gaol. A small section has survived as a retaining wall in Highcross Street next to a house (now a shop), which dates to 1704.

The Free Grammar School

The architecture of this part of Highcross Street has been well documented, not only by Nichols but by local topographical artists, including John Flower. Archaeological surveys, initiated by the development of the Highcross Centre, have added to our knowledge of its history.

The Free Grammar School was enabled to be founded by the wealthy Leicester wool merchant William Wyggeston. It was built in 1573 using timber and stone from the nearby demolished church of St Peter. The school proper had begun within the walls of the old church. It was refounded in 1564 when Queen Elizabeth I made an annual grant of £10 towards the upkeep of the master. It continued as a place of education until 1841, and then served in numerous diverse roles as a warehouse, a joiner's shop, and the headquarters of a bus company. In the twenty-first century, having been carefully restored, it is now a restaurant. Thanks to modern archaeology, stone from St Peter's, over 400 years since it was demolished, was incorporated into the refurbishment.

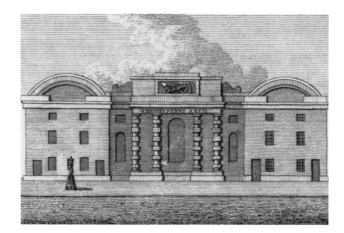

The Borough Gaol, built by George Moneypenny in 1790/02 and demolished in 1897.

Highcross Street and the remains of the Borough Gaol between the present buildings.

Trinity Hospital

Established in 1300/01, of the several hospitals in Leicester, Trinity Hospital is not only one of the oldest, but, with Wyggeston's Hospital, is one of the few to survive and to continue to fulfil their original purpose – although not in the same buildings.

Nichols offers not one but two engravings of Trinity Hospital – one by John Pridden, dated 1776, and the other by Barak Longmate, dated 1796. The need to compare the two images is justified as there were major changes in the space of those two decades.

During the time that Nichols was assembling his work, the hospital was largely rebuilt at the expense of George III, although Throsby believed that as a result the building was 'mutilated, patched and cobbled up', and that the contractor made illegal earnings by selling the lead from the roof. In the first years of the twentieth century, a further rebuilding took place, followed by modernisation in the 1960s. It must be noted that the demolition and rebuilding of a substantial part of the building was to the benefit not of the hospital, but to modern road transport, enabling a new road to be cut across the Newarke and the river.

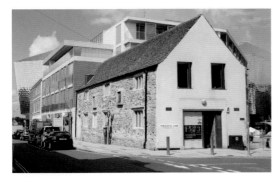

The Free (or Elizabethan) Grammar School,
now restored and integrated into the
Highcross shopping centre.

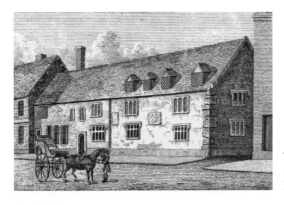

The Free (or Elizabethan) Grammar School in
1796. The engraver's transport awaits him in
Highcross Street.

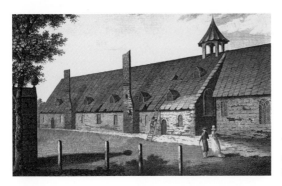

Trinity Hospital in 1790. Longmate's
engraving records work being undertaken
on the roof.

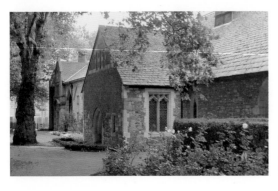

Trinity Hospital in August 2009. The
chapel, which is the oldest part of the
building, is in the foreground.

The Earls of Leicester and Lancaster, who had possessed the castle and its environs since the twelfth century, probably owned the land which was to become their Newarke or 'new work'. In 1330/31, Henry Grosmont, 3rd Earl of Lancaster and grandson of Henry III and Eleanor of Provence, founded the hospital for fifty poor or infirm persons. It was well provided for, and well organised,

His son, Henry, developed his father's plans with considerable flair, extending the hospital buildings to provide accommodation for a further fifty people, and building a large and richly endowed chantry college. This Henry had, in 1349, been arrested in Germany and held to ransom by the Duke of Brunswick. On his release, Earl Henry accused Brunswick of improper conduct who then responded by challenging him to a duel. Brunswick pulled out of the contest at the last moment, and eventually offered an apology to Lancaster through the King of France. Following this incident, it is said that many rich gifts were offered to Henry, but he would accept only one: a single thorn, said to be from the crown of thorns worn by Christ at the Crucifixion, which was later to be enshrined in the church in Newarke.

The destruction of the college and church at the time of the Dissolution appears to have been very thorough, but the hospital was spared. It operates today from modern facilities in nearby Western Boulevard, where new buildings were constructed in 1995. The old hospital building was purchased by De Montfort University and now houses some of its administrative departments. It has been rebuilt on several occasions, and the chapel, where sacred music is still performed on occasions, is the only part of the original almshouse to survive.

In 2014, this ancient building was undergoing further restoration work with the replacement of its roof. The old chapel remains relatively unchanged, and is still a place where the music of all ages can be heard.

Wyggeston's Hospital

William Wyggeston received authorisation to establish his hospital by letters patent in 1513 and 1514. Land between Highcross Street and St Martins' church was purchased and, by 1518, the hospital had been constructed. It was called The Hospital of William Wyggeston Junior, and was dedicated to the Blessed Virgin Mary, St Katherine, and St Ursula and her companions.

William Wyggeston made sure that his hospital was financially secure by endowing substantial tracts of land, which he purchased between 1513 and 1520. These included manors in Castle Carlton in Lincolnshire and Swannington in Leicestershire, and other land in Leicestershire, Lincolnshire and Staffordshire. His widow, Agnes, later bequeathed the lease of tithes in the town's south field, and a further sum of money to the value of £100 was included in William's will.

The buildings constructed by William Wyggeston for his hospital survived for over 350 years. They stood in St Martin's West, close to the west end of St Martin's church, the length of the main building running parallel to the path of that name between Guildhall Lane and Peacock Lane. It was a long building of two storeys, timber-framed and covered with plaster with stone buttresses. The master's house was located at the north end. A section of the wall remains on the boundary with the Guildhall. The building was enlarged in 1730 by the addition of one storey and a sloping slate roof. A small chapel was located at the opposite end of the hospital near to Peacock Lane, which was also restored in 1730. A second set of buildings were later constructed on the western side of

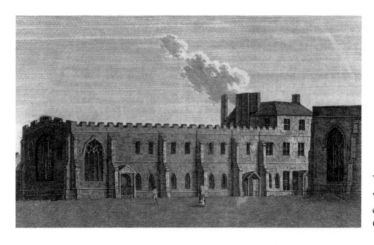

Wyggeston's Hospital
with St Martin's
church (now Leicester
Cathedral) on the right.

the hospital, which contained storerooms and kitchens. The confrator's house formed an
extension at right angles to the main hospital building, with an entrance on Highcross
Street. Completing the quadrangle form was a courtyard and gardens.

The chapel contained a significant quantity of painted glass, most of which was
removed at the beginning of the nineteenth century to the parish church of Ockbrook
in Derbyshire. Some of the windows were blocked up at the same time. The chapel
also contained the tombs and monuments of several of the masters and confraters,
including that of the first master, William Fisher.

The last hospitallers left the buildings in April 1868, and the old hospital then
lay empty for almost eight years. In that time, a powerful debate over the future of
the buildings raged. Then, in May 1874, the character of Highcross Street, between
Guildhall Lane and Highcross Street, changed dramatically. The ancient Nag's Head
public house had stood at the junction of Highcross Street and Guildhall Lane since
at least 1662, and had retained its original wooden porch. Further along Highcross
Street was the confrator's house, constructed in the sixteenth century. Next were a
number of small – and possibly rather dilapidated – residential properties dating to the
middle of the eighteenth century, and at the corner of Highcross Street and Peacock
Lane stood the old Peacock Inn. It was announced that all were to be demolished in
May 1874.

In July 1875, after more than a year of apparent inactivity, an announcement was made in
the local press stating that: 'The whole of the valuable building materials in the Wyggeston
Hospital Buildings, St Martin's West, including a splendid old and massive timbered oak
roof, oak moulded Gothic door were to be sold by auction.' The auction took place on
Monday 9 August 1875. The proceedings were reported in the local newspapers, and the
buildings were demolished 'without delay' according to the conditions of sale. Handcarts
were used by the purchasers to remove stone and other items from the site. The materials
and fittings were sold for £92. The tombs and memorial slabs from the chapel were
removed to the new chapel; the seats from the chapel were given to the Trinity Hospital
and the porches that had faced the path in St Martin's West were given to St Nicholas's
church, together with a niche from the chapel. Two wooden porches in St Martin's West,
which had carved upon them the rebus of William Wyggeston, were not included in the
sale but were donated to the church of St Nicholas.

The Leicestershire Archaeological and Historical Society had campaigned vigorously to prevent the demolition of the hospital, proposing that it could be used as the assembly hall for the intended new school. The eminent local historian James Thompson had addressed the society on the issue at their annual general meeting:

> The proposal to demolish the Hospital of William Wyggeston in this town, with the chapel at its southern extremity, and, consequently, to disturb the remains of the dead lying beneath the floor of the chapel, involves consequences so serious that it behoves the Leicestershire Architectural and Archaeological Society, which professes to regard the preservation of ancient architectural remains as one of its chief objects, to consider well whether it can in any way ward off the blow, or whether it must stand by and witness in silence, and without remonstrance, the threatened violation of the tombs of the dead, and the uncalled-for destruction of one of the few remaining monuments of the piety and charity of the departed benefactors of this ancient borough.

Some of the stone footings of the old chapel are visible above modern ground level in the corner of the land of St Martin's Centre, between St Martin's West and Peacock Lane. In earlier years, when the buildings were occupied by schools, this area was protected by iron railings.

The bruising encounter with 'the authorities', experienced by the Leicestershire Archaeological and Historical Society, was not forgotten. In 1915, an excursion by society members passed by the site of the former hospital as the party walked from the Guildhall to St Martin's:

> From the Guild Hall the party proceeded to St Martin's church, passing on their way the site of William Wigston's hospital, which was ruthlessly pulled down in 1875. The quiet old almshouse, with its chapel, had an air of benediction which evidently did not appeal to the powers that were forty years ago. It is difficult to understand the type of mind to which the destruction of that monument of ancient kindness seemed a desirable act. Members of this society, and others for whom tranquil beauty and old association have a meaning, take another view, and sadly recognise how the town has been impoverished by this needless and unseemly obliteration.

St Martin's House, site of Wyggeston's Hospital, in 2010. The buttress of Leicester Cathedral (*right*) provides a locational comparison with the previous image.

2

Framland

Brentingby

Although less than 2 miles from Melton Mowbray, the small hamlet of Brentingby is remote, accessible only by single track lanes from the Melton to Saxby road. There were just six families in the hamlet in Nichols' time, and there are even less today.

The last service was held in Brentingby chapel in 1950. There followed a quarter-century of neglect until the building was converted into a private residence in 1977. The conversion enabled an archaeological survey to be undertaken.

One of the most enigmatic elements of this little building is the saddleback tower with its 'spirelet' above. The description by Nichols is simply that of 'a small tower with two little bells'. Even the combined experience of artist John Pridden (who visited in 1791) and engraver John Cary failed to represent accurately its architecture. In their illustration, the spirelet appears to rise from somewhere behind the tower.

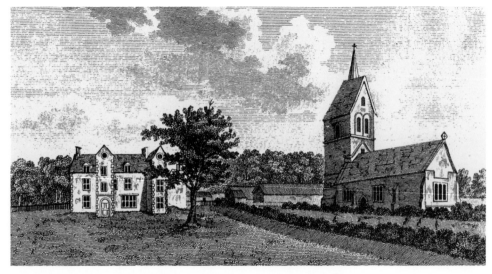

Brentingby chapel and Hall. The drawing by John Pridden emphasises the saddleback tower, which appears too large. The spirelet seems to rise from behind the tower.

One the two bells has survived, and it is one of the oldest church bells in England for which a date can be given – around 1340, cast by Johannes de York. For some years it was stored in Thorpe Arnold church and then at St Mary's Melton Mowbray. It is now the centrepiece of the Bell shopping precinct in Melton.

Pridden's view of the hamlet includes Brentingby Hall, which is situated to the south-west of the chapel. The location of the manor house is not known, but it may have been near the site of the hall. Nichols stated that in 1795–98:

> Mr John Simpson lives in the manor-house, which is prettily shaded by a grove or plantation of trees. He happily enjoys a competency from industry, at an age when numbers do but begin to think.

The fascinating wall paintings, which were revealed during the archaeological survey and removed from the chapel by the Leicestershire Museum Service, are not recorded by Nichols, perhaps because at that time they were covered over. One of these, an image of a man with a club standing near what appears to be water and a tree, was adopted by the descendants of John de Woodford, who held the manor between 1317 to *c*. 1360, and is still used by them today.

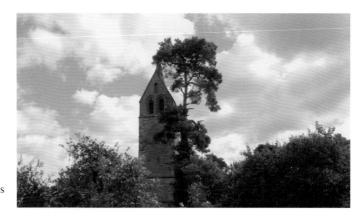

The saddleback tower of Brentingby chapel, which is now a private residence.

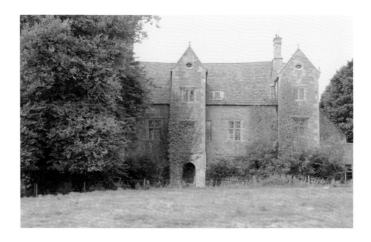

Brentingby Hall, photographed in 2014.

Burton Lazars

'There is something uncommonly salubrious in the air here', writes Nichols, 'as well as the water, which may perhaps increase its effects, situated as it is upon a gentle ascent surrounded by high hills.' He continues, possibly with a reference to foot and mouth disease:

> During the disorders of the murrain among the larger cattle which has happened two or three times in the kingdom, and most alarmingly within a century past, the lands of Burton heretofore the hospital lands, where the pure spring rises, were a happy asylum against the ravages of the murrain.

Nichols was referring to the sulphuric content of the stream near the village, which, it is said, was used by the Hospital of St Lazarus in its treatment of knights who had contracted leprosy. The extensive earthworks associated with the hospital are located around 200 metres west of the present village and main Melton road.

The monument in the churchyard of St James parish church commemorates William Squire, a local weaver, who died in 1781. It is said that his entire fortune of £600 was spent on this memorial, and it must have looked in near-pristine condition when Pridden sketched the church on 23 September 1791. The monument is 6 metres in height, and consists of an obelisk on top of an urn, supported by four real cannon balls. It was listed as 'at risk' by English Heritage in 2014, which reported lamination and deterioration of the stonework and movement of the supporting stepped base. A grant for repairs to be carried out has been provided.

Saltby

Jacob Schnebbelie's engraving of St Peter's parish church is dated 24 September 1791 and is a view from the south-east. It is dramatic, emphasising the elevation and the dominant west window. Today, the church seems much less imposing, and the view is obscured by a line of high shrubs and trees.

Saltby, as its name suggests, is located on the line of the ancient Salt Way, used to convey salt produced by evaporation on the Lincolnshire coast inland, at least as far as Leicestershire and possibly further into Warwickshire. According to W. G. Hoskins, the route was used as early as the Bronze Age and served in the Roman period to connect Ermine Street and the Fosse Way.

Nichols notes that at the beginning of the eighteenth century, Saltby Heath was famous for horse racing, promoted principally by the Dukes of Rutland. He includes an observation by Francis Peck of a meteor: 'Whose lambent pale flame all about them sticks, and frights them strangely with its harmless tricks. So many fancies it will sometimes, shew, that even no phosphorus can its tricks outdo.'

In a footnote, Nichols comments that the meteor is usually referred to as *Ignis lambens*, a phenomenon described in literature in the eighteenth century as a 'gentle flame' rather than an all-consuming fire, and similar in effect to the descriptions in the Bible of fire indicating the presence of God or the Holy Spirit. The cause appears to be an electrical discharge of much lower intensity than lightning but of a similar nature, and commonly described as static electricity.

Nichols clearly disapproved of the gambling that had taken place in Saltby, associated with the races:

> The races were upon the decline for 40 or 50 years, and entirely ceased at the inclosure, when the stables became useless, and were consequently destroyed ... It is happy for the neighbourhood that there is an end of all this, as the inhabitants had not the sagacity common in most public places to profit by the folly of others, but neglected their business, and became gamblers and companions of grooms. The village has yet the appearance of poverty.

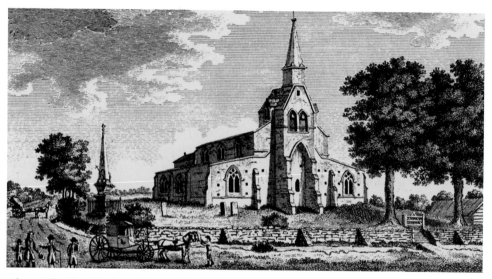

Above: The church of St James, Burton Lazars, with members of the Nichols family in the foreground.

Below: The Squire Monument in Burton Lazar's churchyard.

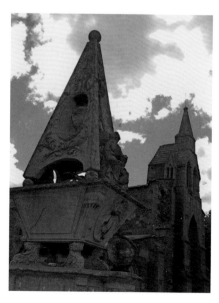

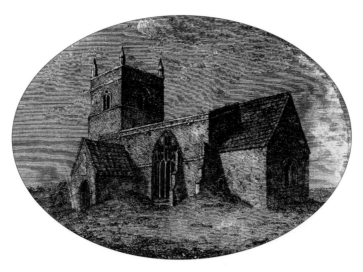

Saltby, the church of St Peter, engraved by Jacob Schnebbelie (1791) showing the ground raised against the chancel and south porch walls.

The livestock in Saltby apparently fared no better. Nichols notes that 'the heath ground ... is very poor and unwholesome for cattle. The sheep that feed on it often die mad of the wool-evil.'

Crossing the heath is a bank and ditch approximately 2 miles in length and known as King Lud's Entrenchments, which are possibly Bronze Age. There are numerous hypotheses regarding their origin and purpose. Pevsner suggests that they served as a line of demarcation between two kingdoms. Nichols provides measurements for the various barrows, pits, ditches and banks, but warns that, 'the dimensions of the whole were taken only from pacing and memory; accuracy is therefore not asserted.'

Scalford

The church stands on a small hill in the centre of the village and is named after St Egelwin (alias St Ethelwin) the Martyr. It is probably the only church in England named after this obscure saint. The church was built mainly in the thirteenth century, and restored in 1859.

Given the proximity of Scalford to Lincolnshire, it is possible that the church is dedicated to Ethelwin, Bishop of Lindsey and a friend of the Abbot of Peurtney in Lincolnshire. This Ethelwin's diocese spanned roughly the area of modern Lincolnshire. His feast day is either 3 May or 29 June.

The other, and more likely, candidate is Ethelwin (or Ailwin or Egelwin) who was a monk and hermit in the seventh century in Athelney in Somerset, and was described as 'a confessor and a prince of the House of Wessex' and, in other references, as 'Prince of Athelney'. He is said to have been the son of Cynegils, king of the West Saxons 611–42, and brother of Cenwalh (or Kenewalch), king of the West Saxons 642–72. He was reputed to have experienced ill health all his life, but to have been a remarkable posthumous healer of the infirmities of his followers, with Athelney being the centre of his cult. The abbey at Athelney was dedicated to him. His feast date is given as 29 November, but the church holds its Patronal Festival on 26 September. The Wake used to be held on the first Sunday after 29 September (Michaelmas).

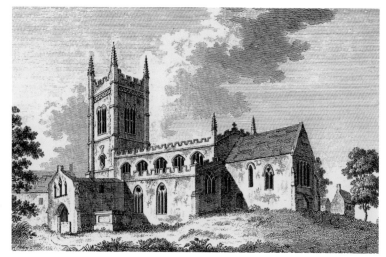

Scalford, the church of St Egelwin, engraved by Jacob Schnebbelie (1791). The chest tomb is in the same position today.

Nichols' engraver, Jacob Schnebbelie, visited Scalford on Sunday 20 November 1791 – in the mid-afternoon, judging by the shadows being cast. In the churchyard are four limestone chest tombs and the base of a medieval cross, all of which are now listed. The chest tomb near to the south porch in Schnebbelie's engraving has an inscription now much faded, which bears a date of possibly 1719. It is still in the same location today.

Somerby

There are numerous weathercocks in the thousands of engravings of churches in Nichols' history. Over 200 years after Schnebbelie engraved the weathercock on top of the spire of All Saints' parish church in Somerby, its Victorian successor became a part of the history of the Second World War and the role played by the Parachute Regiment's 10th and 156th Battalions in the ill-fated Operation Market Garden.

Prior to the operation, which was an audacious plan to break through into Germany over the Lower Rhine, the 10th Battalion was billeted here. During that hot summer, as they waited for their orders to mobilise, the men were kept awake at night by the incessant squeaking of the weathercock on the spire of All Saints'. One soldier, Lt Pat Glover, eventually took decisive action and shot at it four times.

The battalion subsequently left for Arnhem from the nearby Saltby airfield. After days of fierce fighting, they were defeated by the Nazis and suffered heavy losses. Their story was dramatised in the film *A Bridge Too Far*. Of the two battalion's 1,200 men, only 70 returned to Leicestershire.

In October 2013, a special ceremony and services were held to honour those who fell as part of the battalion's 156th annual reunion.

The weathercock survived until 1989, when it was replaced during renovation work and donated to the Regiment to become the battalion's shooting trophy. In September 2014, it was regilded and returned to the church. It was placed next to the commemorative stained-glass window that honours the young soldiers of the 10th Battalion.

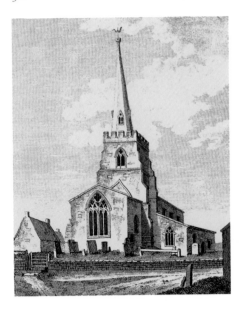

Somerby, the church of All Saints. The village pump has survived, but is now in a private garden.

Sproxton

The church is at a distance from the village, standing on a bend on the Saltby Road, as Nichols remarks:

> The church, dedicated to St Bartholomew, stands high, and much exposed to the West; it is nearly a quarter of a mile from any house, and double that distance from the greatest part of the town, yet the inhabitants are remarkable for their constant attendance on divine worship.

The reason for its present isolation is that the manor house, now demolished, was located near to the church. Nichols notes that remains of the buildings were still evident in the landscape when he was compiling his history.

The church is not aligned to the east, but to the north-east, and it is possible that this is a deliberate alignment with the rising sun on 24 August, being the Feast Day of St Bartholomew. In Nichols' engraving all the tombstones face north, but are now all turned to the south-west. The history of the church was strongly influenced by the Abbey of Croxton, which was located less than 5 miles away and, for some time, the Abbey held the advowson.

There has been significant refurbishment of the building since Nichols' time, including additions to the north isle and rebuilding of the north porch. The church was restored in 1882–84. In the churchyard near to the south east of the porch is an ancient stone cross, once used as a footbridge over a small stream. It is the only complete pre-Conquest cross in Leicestershire. The shaft displays interlace and beasts, and stands in its original socket. Taken down at the Reformation, it was rediscovered by William Mountsey, the vicar of Sproxton between 1791 and 1818.

The manorial history of Sproxton is bound up in the inter-marriages of significant medieval landowning families, particularly Brabazon, Trussell, Neville, Folville and

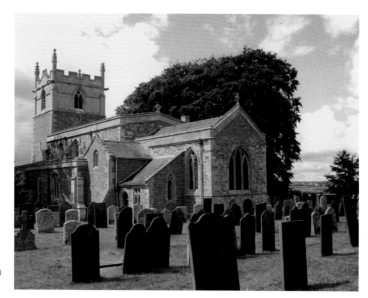

Sproxton, the church
of St Bartholomew.
The south aisle and
chancel have been much
restored and altered.

Woodford. All accumulated considerable land and wealth in the Hundred of Framland
over several centuries. Of these, the Woodford family was probably the last to establish
itself in the area, but by the time of the death of Sir Robert Woodford, Lord of Sproxton
in 1455, their amassed fortunes had been lost due to a rift between Robert and his
grandson Ralph of Ashby Folville.

The Woodford Cartulary devotes forty-eight pages to the family's land transactions
and history relating to the manor of Sproxton. Nichols quotes extensively from it. He
reproduces several pedigrees of the Woodford family, but they are all different.

The family's first land purchase in Leicestershire was the manor of Brentingby,
purchased by John Woodford in 1317. The Woodford family acquired the manor of
Sproxton through the marriage of his only (surviving) son, William Woodford (who
died in 1369), to Joan Brabazon. Their only son, John (1358–1401), was a minor when
his father died, but gained the manor on his twenty-first birthday. John married Isobel
Folville. Their only son, Robert (1383–1455), who was also a minor when his father
died, married Isabel (Maud) Neville. These marriages brought very considerable land
and wealth into the Woodford family, but very few heirs. Sir Robert Woodford and
Isabel Neville had seven sons, but only one grandson – namely Sir Ralph Woodford. Sir
Robert's eldest son was Thomas Woodford, who married his cousin Alice Berkeley, the
daughter of Sir Lawrence Berkeley of Wymondham and Joan Woodford, sister to Sir
Robert Woodford. Their son Ralph was born in 1430.

Thomas died before his father, and Ralph would therefore have become heir
to his grandfather's estates, except for Sir Robert's disapproval of his marriage to
Elizabeth Villiers. The reason for Sir Robert's strong dislike of the Villiers family is not
explained, but it resulted in Robert attempting to disinherit Ralph by sharing out the
family's assets between his sons. As a result, as William Burton notes, the family lost
the majority of their lands: 'By reason of which division so made, that ancient family
(which had continued many years in great account and high dignity) was, in a short
space, utterly decayed and gone.'

The most glorious years of the Leicestershire Woodford family were undoubtedly the period when they owned the manor of Sproxton, and when Sir John and Sir Robert Woodford lived in the manor.

Burton recorded six coats of arms in the windows of the chancel for his *Descripton of Leicestershire* (1622), but only one survived to 1729 when Francis Peck, the antiquary and local clergyman, visited the church. Recently, these arms have been reproduced on kneelers, which are kept on the pews in this area of the building.

Two of the bells that hang in Sproxton church were cast by Johannes de York. The dating of the bells and the belfry would suggest that these were commissioned by John Woodford. It is fascinating to note that John was baptised in Brentingby chapel, where another bell by Johannes de York would no doubt have rung out following the ceremony – that bell having been commissioned by John's grandfather, the earlier John Woodford, who was the first member of the family to set foot in Leicestershire.

Stapleford

This elegant church, dedicated to St Mary Magdalene, and built in the Gothic Revival tradition is now in the keeping of the Churches Conservation Trust. Its setting in the grounds of Stapleford Hall, transformed out of a former deer park by Capability Brown, is exquisite. It was built in 1783 by the Scottish architect George Richardson (1737–*c*. 1813) and has been described as an 'almost perfect time capsule of early eighteenth-century taste'.

The hall was originally the seat of the Sherard family, who later became the Earls of Harborough. The church was commissioned by the fourth Earl of Harborough, and the family's links with numerous other major Leicestershire landowning families is recorded in a series of thirty-eight coats of arms incorporated into the fabric of the building and detailed by Nichols.

From 1894, the Gretton family held the estate until the hall was purchased by the American 'pizza millionaire' Bob Payton in 1988. Restoration work on the hall took place in 1931 and 1967, but Payton undertook major redecoration, employing top designers, consequently reopening the building as an upmarket hotel and country club.

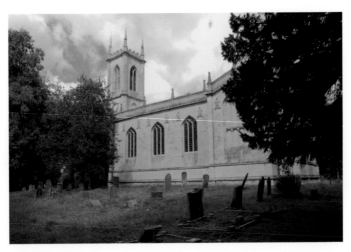

Stapleford, the church of St Mary Magdalene. A building of great dignity, and perfectly suited to its location.

Payton was an immensely entertaining and flamboyant man who genuinely valued 'Englishness'. He could also appreciate self-deprecating humour, once participating in an April fool's joke on BBC Radio Leicester where he convincingly told listeners that he had bought Bradgate Park near Leicester, and was planning to farm deer and sell venison burgers from 'Old John', the familiar folly in the park.

If he had owned Stapleford when Nichols was compiling his history, one would have expected Payton to have been the subject of one of Nichols' colourful footnotes, and that Payton would have felt honoured to have been mentioned. He died in a motor vehicle accident in Stevenage, Hertfordshire, in 1994.

Engraved in the stonework of Stapleford Hall is the inscription: 'William Lord Sherard, Baron of Letrym, repayred this building, Anno Domini, 1633.' Below is a later addition that reads: 'And Bob Payton did his bit. Anno Domini 1988.'

Thorpe Arnold

Although archaeological excavations have taken place in the area of Thorpe Arnold known as Hall Close to the south-west of the church, comparatively little is known of the village's pre-Domesday history.

The nave of the church of St Mary the Virgin dates from AD 800, with much of the present building constructed around 1150, although there have been several phases of rebuilding and repair since Nichols' time. The font is also ancient – dating from AD 850. In the 1860s, the entire building above the clerestory level was taken down and reconstructed.

Nichols states that Ernald de Bois, steward to Robert 'Le Bossu', otherwise Robert de Beaumont, 2nd Earl of Leicester (1104–5 April 1168) occupied a residence in Thorpe Arnold. The earthworks in the Hall Close area, on the edge of a slope down towards the River Wreake, are certainly suggestive of a site occupied over several periods from pre-historic to medieval, and at some stage could have been the location of a moated manor house.

It appears that in the late eighteenth century, when Nichols was compiling his work, the economy of Thorpe Arnold was poor. Nichols, quoting possibly the incumbent of the village, Revd George White, explains that this is:

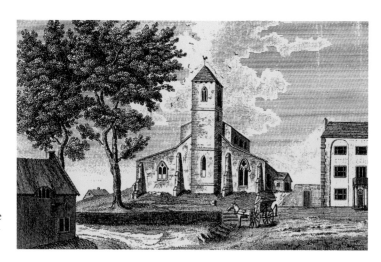

Thorpe Arnold, the church of St Mary the Virgin as engraved by John Pridden (1793).

Due mainly to the fact that 'little more than 400 acres of land, out of 1740 which the lordship contains, are occupied by its inhabitants; and that the best part of the land, both in respect to quality and quantity, is let to tenants who reside at a distance from the place.

The consequence of this was that many houses had been neglected for so long they had become ruinous. The vicar for some years had conducted services in the chancel wearing a covering on his head because the area was open to the elements. The engraving, by Revd John Pridden undertaken in 1793, does not reveal any neglect.

This page of illustrations, which include Brentingby, is dedicated to Pridden 'by his affectionate father-in-law, J. Nichols'. There follows what would not be out of place today in an estate agent's brochure:

There are few places in the county which command more extensive or varied views, few situations which enjoy so clear and uncontaminated an atmosphere. Its proximity to Melton Mowbray affords all the advantages and convenience of a town residence; whilst those of the country are amply contained within itself: and, as if Nature designed this village to enjoy whatever was conducive to health, there is on the South-east of it, adjoining the road leading to Brentingby, a chalybeate spring, the virtues of which, if more generally known, would no doubt be generally esteemed. It is in taste and quality like one of the springs at Scarborough, which several medical writers have reckoned equal to the celebrated German Spa.

Presumably the vicar was hoping to increase his flock and the value of his living.

Withcote

John Pridden sketched Withcote Hall in 1793. The hall was then almost seventy years old. It had been built by Matthew Johnson, the son of a yeoman from Gretton in Northamptonshire, who was from a relatively humble background but had achieved considerable career success, being called to the bar in 1671 and later obtaining the post of Clerk of the Parliaments, which he held for twenty-six years.

Early in the reign of Charles II, Johnson purchased the lordship of Withcote from the Earl of Rochester, to whom it had been given by the king. The former owner, Henry Smith, had been forced to forfeit it because of the part he played in the execution of Charles I. Matthew Johnson died on 13 December 1723. He and his wife, Margaret, lie buried in the chapel.

In recent years, the hall has suffered badly from neglect. Water seepage through the roof caused serious rot to the fabric of many of the rooms. In 1999, English Heritage and Harborough District Council commissioned a survey of the damage. By 2004, it was found that the roof had been repaired and the building was dry. Although the hall is still listed by English Heritage as being at risk, at least some of the underlying causes of the damage have been addressed.

However, it appears that there is still work to be done. When the author visited Withcote on 12 April 2012, the roof and windows of the East wing appeared to be in reasonable condition. Two years later, a photograph from a similar position indicated that the dormer window had fallen in and part of the roof was missing.

In his sketch, Pridden chose a perspective that included both the hall and the church. The view is from the south, but cannot be seen today because the church is surrounded by trees. Pevsner describes the position of the house and church, and their relationship to one another as 'delightful', and the hall as an 'extremely lovable' house. The church is recorded by Nichols as, 'This beautiful little fabrick, resembling an elegant college chapel ... adorned with large pinnacles, very perfect Gothic. ' Regarded by Alec Clifton-Taylor as one of the best English parish churches, it was originally the private chapel for the hall and is now in the care of the Churches Conservation Trust.

Wyfordby

The village of Wyfordby, in the time of Nichols and indeed the present century, is small, but it is has been occupied since the Iron Age.

The medieval village was abandoned in the fourteenth century, possibly due to a sharp decline in the population cause by the plague. A new village was built immediately to the north, and near to the church.

Archaeological investigations in 2002/03 revealed the deserted medieval village, with a moat, fishponds, house platforms and hollow way. Pottery finds dated to the

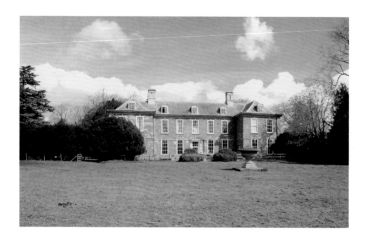

Withcote Hall, photographed in 2012.

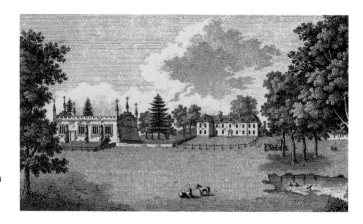

Withcote Hall and church sketched by John Pridden in 1793.

Iron Age, Roman, Saxon and medieval periods. Five buildings were also identified including a probable Iron Age roundhouse and an early Saxon structure.

Nichols reproduces an illustration of the village in 1793 by James Basire, sketched from the lane that leads to Stapleford, looking to the west, and showing the junction with the lane that leads north to the main Melton to Saxby road. It is almost a fleeting glimpse as if Basire looked over his shoulder as he rode out of Wyfordby, saw the settlement, with its church, in the valley, stopped and began to sketch.

Wymondham

Evidence of Neolithic, Iron Age and Roman occupation has been found in Wymondham. Clearly, the geographical location of Wymondham, close to the borders with the counties of Lincolnshire and Rutland, and on the main route from Melton Mowbray to the Great North Road, made the village an important settlement.

Nichols, in considering the origin of the name of the manor quotes the following from Revd Francis Peck: 'There was one Wymand, (Wygmund) son of Witlaf, (827–840) king of the Mercians; and this town being in that province, probably he had it for part of his maintenance, and so gave name to the place.'

As Nichols shows, two families have played an influential role in the development of Wymonham – the Berkeleys and, more recently, the Sedleys. The Sedley family were from Kent, and their first association with Leicestershire was probably through the friendship of Sir William Sedley and Sir Henry Berkeley who met on 29 June 1611, the day they were both created baronets.

The Sir John Sedley Educational Foundation, endowed in 1637 with £400 for the purchase of farmland, is still active today, and that initial funding has increased to more than £500,000. It continues to provide funds for young people in Wymondham and the nearby parishes under the age of twenty-five years for further education of an academic or vocational nature. Over the centuries, the foundation has also funded the building and operation of two schools. The first school was in a small building which still stands next to the church. The later grammar school, which dates to the nineteenth century, is on the outskirts of the village. The Foundation has more recently funded the community centre, and current projects include the establishment of an information technology centre and the provision of tennis courts.

In a footnote, Nichols includes item of gossip about one previous member of the Sedley family who was a playwright and actor of considerable renown:

> At the acting of (his) play, the roof of the playhouse fell down; and, what was particular, very few were hurt but himself. His merry friend sir Fleetwood Shepherd told him, 'There was so much fire in his play that it blew up the poet, house, and all.' He told him again, 'No: the play was so heavy, it broke down the house, and buried the poet: in his own rubbish'.

Some years after the publication of the Framland volume, an unusual event took place on a field outside the village where the boundaries of Leicestershire, Lincolnshire and Rutland meet. Known as Thistleton Gap, this was the location of the first ever International Prize Boxing Match, when on 28 September 1811, Tom Cribb of England defended his title against Tom 'The Moor' Molyneux of America and won £2,600 and a cup.

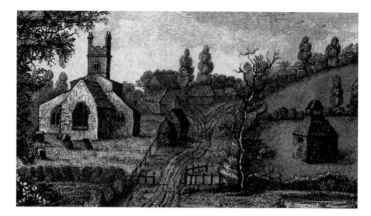

Wyfordby village. The view is west from the lane from Stapleford, as engraved by James Basire in 1793.

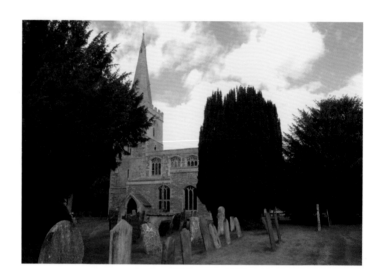

Wymondham, the church of St Peter in September 2014.

The crowd who gathered to watch the spectacle was estimated at between 15,000 and 20,000, and many chose to place a bet on the result knowing that they could probably avoid arrest by the magistrates from any of the three counties by crossing the border from one to the next. In fact, it was rumoured that some of the Rutland magistrates attended the match. The fight lasted less than twenty minutes. Cribb had his jaw broken, but won the match in the eleventh round and danced a celebratory hornpipe in the ring. Molyneux was knocked unconscious.

Molineux's boxing career ended four years later. His was a short and sad life. He had been born into slavery on the plantations of Virginia, and took up bare-knuckle boxing as a means of escaping to freedom. Soon after his fight at Wymondham he spent time a debtors' prison, became increasingly dependent on alcohol, and died penniless in Galway, Ireland, from liver failure. He was just thirty-four years old.

Cribb retired to Woolwich in south east where he died in 1848, aged sixty-six. He was buried in the churchyard of St Mary's and St Andrew's in Woolwich, where a monument to his memory was erected. A road in the former Royal Arsenal has also been named in his honour.

3

Gartree

Blaston

The ecclesiastical allegiances of the two modest little chapels in Blaston, separately dedicated to St Giles and St Michael, and engraved for Nichols by Barak Longmate in 1794, echo the ancient rivalries of the neighbouring villages of Hallaton and Medbourne. St Giles has been long associated with Medbourne, and St Michaels with Hallaton. It was not until the twentieth century that they were united to create one ecclesiastical parish.

It is said that St Giles was founded by Richard I. Nichols informs us that this was in recognition of the gallantry of Hugo de Nevill:

> By king Richard I, the lordship of Blaston was given to Hugo de Nevill, a valiant knight, who being a servant in court to king Richard the First, was in 1193 with that king in the Holy Land, where he performed the part of a stout soldier; and likewise flew a lion by a shot with an arrow into the breast, then piercing his body with a sword.

St Giles served the greater part of the valley in which Blaston lies. For centuries it was associated with Medbourne, but maintained its independence as a free chapel with no obligations other than the payment of a pension of 5s per year, which allowed parishioners from Blaston to be buried there. Nichols believed that the chapel's independence arose from being founded on royal demesne. It was rebuilt between 1710 and 1714 with a round-headed doorway, two-light mullioned windows and a small bell-cote, and it is this building that is illustrated by Longmate, with a nave and small chancel and measuring just 50 feet 6 inches in length.

Both chapels were rebuilt again in 1878 by the Revd G. C. Fenwicke. The architect was George Edmund Street, who also designed the parish church of St Peter's in Highfields, Leicester.

The chapel of St Michael is first mentioned around 1220 as belonging to that part of Hallaton church owned by the Martival family, and was even smaller than St Giles, being only 33 feet 6 inches in length and 17 feet 6 inches in width.

The small chapelry of St Michael comprised the eastern part of the village and a number of fields, and was served for three days of each week from Hallaton. The paddock, to the south of the main street in which the chapel is situated, was owned by the rectors of Hallaton until it was sold in recent years.

St Michael's seems to have been kept in very good condition in the seventeenth and eighteenth centuries. Longmate's engraving shows it as a simple post-Reformation building with square-headed windows and gables with parapets, but in 1838 the archdeacon reported that the roof was in disrepair and the east and west ends were cracking away from the side walls. In 1842, he described St Michael's as 'a most mean building in a dilapidated condition, its timbers rotten, slates loose, and ceiling falling'.

The chapel was allowed to fall into worsening disrepair. In 1858, it was described as 'dilapidated, dirty and dangerous'. Finally, in 1878, it was rebuilt, and services continued to be held there until around 1922. It was partly demolished in 1967, and is now an evocative ruin in a very peaceful setting.

Burton Overy

The former name of this village was Burton Novery (according to Nichols and subsequent historians) and was inherited through descent and marriage by Sir Hugh Meighnell (or Meynell). The village is smaller than it was in medieval times, and aerial photography still shows the extent of the larger earlier settlement to the south of the present village, as well as extensive ridge and furrow.

Nichols notes the first performance of the oratorio by George Frederick Handel, *Messiah*, in the neighbouring village of Church Langton on 26 September 1759, arranged by the resident rector, botanist and philanthropist, Revd William Hanbury. In the churchyard at Burton Overy stands a memorial stone of Swithland slate for Thomas and Mary Neale, which has on its face a line of music from *Messiah*, namely the phrase, 'I know that my redeemer liveth'. Local legend suggests that the young man who lies buried beneath this memorial took part in that original performance. The year of the interment was 1817 – later than Nichols' publication date.

William Hanbury in his diaries, which are quoted extensively by Nichols, says that after the first dramatic performance the church doors at Church Langton were 'flung open', and the entire work was performed again so that all those outside could hear it.

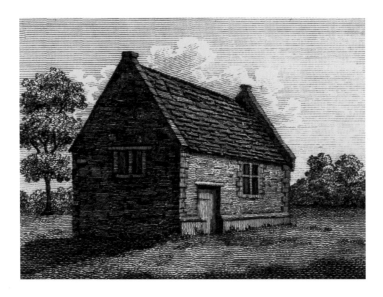

The chapel of St Michael as illustrated in Nichols.

In the eighteenth century, before the noise of steam or internal combustion engines, it is certainly possible that that second open-air performance could have been heard as far away as Burton Overy.

In 2014, major remedial work required that the church be enshrouded in scaffolding, and with fencing to prevent the theft of lead. The chancel-chapel valley gutter has failed leading to water ingress. Roof timbers in close proximity had suffered significant deathwatch beetle attack.

Cranoe

The church of St Michael stands high above the village, yet its modest proportions do not suggest an overpowering influence on its small parish. Except for the tower, it was totally rebuilt in 1846–49, but a plain circular font survives from the twelfth century.

The land which Cranoe occupies is still owned by the Brudenell Estate. Reflecting a previous period of land management, all the property in the village except for the church is rented from the estate.

John Harwood Hill (1809–86) was the rector of Cranoe from 1837 until his death. He was the author of *The History of the Hundred of Gartree*, which made extensive use of Nichols' work. It was published in two parts – a history of Langton in 1867 and a history of Market Harborough in 1875. The Langton volume was intended as a means of raising funds for the rebuilding of Tur Langton parish church in 1866. Harwood Hill believed this to be: 'A lasting record of one of the greatest church restorations ever made within the memory of man, in any one parish of the Archdeaconry of Leicester, or Diocese of Peterborough.' The result was the parish church of St Andrews, designed by the Leicester architect, Joseph Goddard. Despite Harwood Hill's enthusiasm and commitment, the majority of the funding came from the charity established by Revd William Hanbury at Church Langton.

In August 1846, the church at Cranoe was severely damaged in a storm. Through Harwood Hill's efforts, the new church was built in 1849 by subscription. The church of Welham was also restored during his incumbency, and in 1838, the rectory house

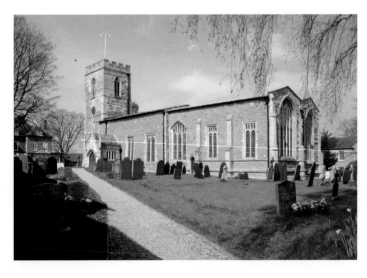

Burton Overy, the church of St Andrew in March 2014 before major refurbishment commenced.

at Cranoe was rebuilt, mainly at his expense. In 2006, one of the larger stained-glass windows from the church was stolen.

Foxton

The parish church of St Andrew stands on high ground south of the village, dominating the village and visible for a considerable distance. It is built of ironstone with some limestone facings, and consists of chancel, clerestoried nave, north and south aisles, north porch, and west tower.

Nichols records this church at a critical moment in its long history. It was reported by the archdeacon in 1797, just a few years after the engraver, Jacob Schnebbelie, visited Foxton, that the church was very dirty: 'the seats wretchedly bad, the roof leaky, the walls defective, and the interior in need of plastering'.

Schnebbelie, who sketched the church on 18 September 1792, provides some details about these defects. His engraving shows that the external plaster has fallen away from the stone work above the eastern window, and the roof timbers at the east end seem to be exposed.

The archdeacon's comments apparently prompted action because, by 1806, the church was recorded as in good condition. The quaint south porch was demolished in the refurbishment two years later.

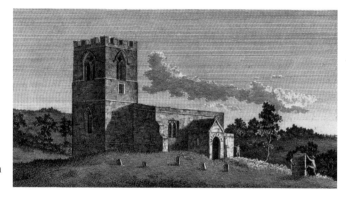

Cranoe, the church of St Michael. The building was severely damaged in a storm in August 1846.

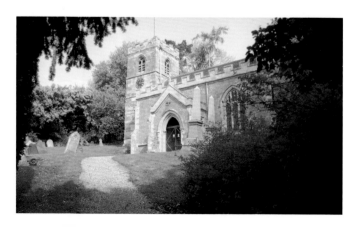

Cranoe, the church of St Michael. The new church, built in 1849.

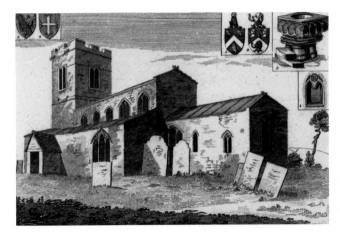

Foxton, the church of
St Andrew, with clear
indication of the need
for renovation.

Schnebbelie's view is from the footpath that crosses farmland from Swingbridge
Street to the Gallowfield Road near Foxton Primary School. The exact view is now
obscured by the Old Mill House and its gardens, which occupy land between the
footpath and the curtilage of the churchyard. The modern photograph is taken from
approximately 10 metres north of the original viewpoint.

Foxton church stands on the highest point in the area, but the engraver has worked
from a low perspective to achieve a sense of height.

Since Nichols' time the tower has acquired its clock, but the structure of the church
has changed little, despite the extensive eighteenth-century refurbishment.

The two Swithland stone memorials in the centre of the engraving have survived in
what appears to be their original locations, although they may have been turned round
to face the opposite direction at some time. The date on one of the memorials is 1775.

Nichols was fortunate in obtaining the wealth of information he did from Foxton
because from 1739 to 1876, the parish was without a resident vicar.

Gumley

The shadows of life in Gumley at the time when John Nichols' friend and fellow
antiquary, Joseph Cradock, built the hall are still apparent today. All that now exists
are some of the outbuildings and the generating station that was built to supply gas
and later electricity to the building. The hall was constructed in 1764, and drawn and
engraved for Nichols by Barak Longmate just thirty-two years later, when it must have
looked fresh and in fine condition.

The evidence of how the settlement existed in a much earlier time is also visible,
including the site of the original village before it was cleared to make way for the hall.
The main entrance to the hall faced south-westwards at the end of a short avenue
of trees. The village street, which used to run directly to the church between this
avenue and the hall, was diverted to create the present sharp curve in the road around
the edge of the hall's precincts, with the former walled garden on one side and the
woodland of the estate on the other.

Gumley has a rich history. Its first documented reference is in 749 when King
Aethelbald of Mercia, who ruled from 716 to 757, held a synod in the village at the

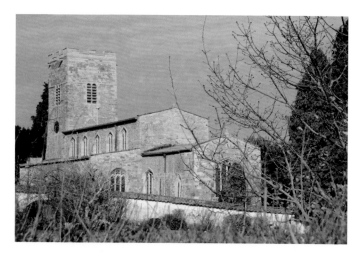

Foxton, the church of St
Andrew, photographed
in 2014.

Gumley Hall and the
church of St Helen.

instigation of St Boniface to respond to accusations that the king had been oppressing
churches and monasteries. The importance of this event was that Aethelbald released
the church from all public burdens except the three common burdens of providing
military service, building and repairing bridges and fortresses. Arguably, these
obligations triggered changes in the land tenurial system of England, which eventually
led to the practice of serfdom.

This settlement was also a meeting place for the *witanagemot* of the kings of
Mercia in the eighth century. The area near to a small pond, which stands in a natural
amphitheatre and is known locally as the Mot, may be a Saxon site.

The church of St Helen now stands isolated, just above 500 feet, in the grounds of
the former hall, surrounded by woodland.

From 1946 to 1948, Group Capt. Leonard Cheshire VC rented the hall, which was
converted into flats as an experiment in community living for ex-servicemen and their
families. The hall became increasingly dilapidated and was demolished in 1964.

Gumley. The church of St Helen provides a reference for the site of the former hall.

Kibworth

The engravings in Nichols' work show the splendour of St Wilfrid's slender spire, which could be seen at some distance from the surrounding countryside of High Leicestershire. The illustration of the church viewed from the east end is by James Basire from an engraving by Jacob Schnebbelie, undertaken on 25 September 1791. Nichols was indeed very complimentary about the spire:

> The steeple is an exceedingly well-built sexangular spire, about 53 yards in height, on a large square without battlements or pinnacles, and contains a musical peal of six bells, founded in 1732. It was probably erected posterior to the church, as its materials seem to be not only superior in quality, but newer than those which compose the church. The steeple was repaired, the church new-floored, and some other improvements took place in it, in 1778, at the expence of £80.

However, in the summer of 1825, Joseph Cradock of Gumley, to whom Nichols dedicated his Gartree volume, wrote excitedly to his friend:

> Kibworth Church fell down. Part had been underbuilt for the new gallery and organ [...] The bells at Kibworth were all destroyed by the fall. Cradock has heard from the Master [Stratford] who is wrathful about Kibworth church. [...] Cradock held the School Meeting in it and then with Sir H[enry] H[alford] and others had lights to examine the records under part of it. [...] Mr Parson of Leicester is architect for the gallery.

Nichols expanded on the dramatic event in *The Gentleman's Magazine* of August that year:

> At 9 o'clock in the forenoon of Saturday last (Ed. 23rd July, 1825), the ancient and venerable tower and spire of Kibworth Church fell to the ground. Various symptoms of decay, about the lower part of the S.W. angle, had been discovered, and partially remedied, above 2 years ago. The originally defective materials having, since that period,

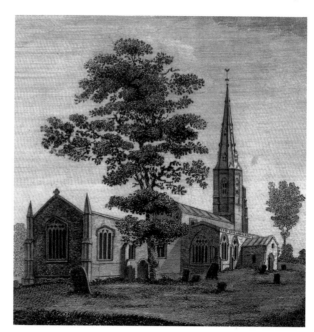

Kibworth, the church of St
Wilfrid, with the fine spire
which fell down in 1825.

more visibly yielded to the pressure of the superincumbent mass, Mr. Wm. Parsons, of
Leicester, was called in about a month ago to inspect the state of the tower, and, under
his direction, the masons had made considerable progress in the work of reparation.
On Thursday last, however, the fissures and which had appeared in numerous places
– were found to have increased in so alarming a degree, that Mr. Parsons was again
summoned without loss of time. On his arrival on Friday morning, he ordered that the
tower should be propped with inclining beams, till permanent support could be given,
by removing all the decayed parts and supplying their place with strong masonry. The
carpenters began their operations on Saturday morning, but were almost immediately
compelled to desist. Violent disruptions in various places, accompanied by threatening
sounds were now incessantly going on, and the site was left to its inevitable fate.

A short time before the final event, I had been informed at the Rectory that Mr.
Oldfield, who had just arrived from Leicester, for the purpose of beginning to paint the
pews, desired to see me at the Church. Unacquainted as yet with the imminent danger,
of which Mr. Oldfield had been equally ignorant, I immediately went to Church, entered
at the Chancel door, advanced towards the West end where the mischief was gathering,
heard the noises before mentioned, suddenly retired by the same door, proceeded round
the East end towards the North gate of the Church yard and there found the different
workmen with a few other persons intensely watching the steeple, and, as they told me,
every moment expecting its fall. I took my station among them, and in less than a minute
after several premonitory crashings, the whole fabric bowed from the summit over the
base, paused for a few seconds, and then, as with one collective effort, came down in
a thundering cataract of ruins. A thousand years could not efface the impression made
upon soul and my senses by the grand, the astounding catastrophe.

Through the immediate and most merciful interposition of God's providence not a
life was lost, not the slightest bodily injury sustained by human being.

William Parsons, the consultant architect and engineer, was educated in Leicester and apprenticed to local architect, William Firmadge. He succeeded his father as steward to the Corporation of Leicester, and was appointed surveyor to the trustees of several of the principal turnpike roads leading out of Leicester.

One of his first public works was the church of St George in Leicester, built in 1825 from his designs. He went on to design and build many of the public buildings in the town, including churches, the county gaol, the union workhouse (Hillcrest Hospital), and two banks. He was also involved in the restoration of the Newarke Gateway. His record suggests that whatever caused the collapse of the Kibworth spire, it was not Parson's workmanship.

Newtown Harcourt

A period of neglect, resulting in the need to rebuild and restore decaying fabric and structures, has been the fate of many of the churches illustrated in Nichols. St Luke's in Newton Harcourt is no exception. It was built as a chapel of ease in the thirteenth century, simply designed with a nave and west tower. It is thought that the lower part of the tower was constructed with stones from the nearby riverbed.

By 1619, the church was in need of repair and painting, and in 1626 the church door was said to be broken and the box pews rotten and decayed. In 1777, the archdeacon ordered a new pulpit, reading desk, communion table and rails, font, and service books. The pavements and chalice cover needed repairing. The seats were beyond repair, and new ones were installed by 1784. In 1797, just two years after the publication of the Gartree volume, it was ordered that weatherboards were to be put up at the belfry windows, the tower buttresses strengthened, and the roof repaired.

It seems that this was not enough. One generation later, Archdeacon Bonney noted that the body of the chapel was almost literally falling to pieces. It was rebuilt with new furniture and fittings, and a large gallery in the lower part of the tower. A brick vestry was added later.

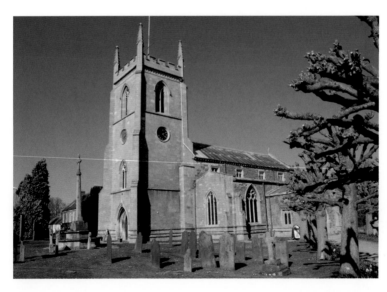

Kibworth, the church of St Wilfrid. The tower rebuilt but without a spire, photographed in the spring of 2012.

The church is now separated from its village by two forms of transport and communication – the canal and the railway.

Shangton

The small village of Shangton lies at the very heart of the Gartree area:

> Nearly in the centre of it is a place dignified with the name of Gartre Bujh, where, till the beginning of this century, were held the county courts, now kept at Tur Langton. The situation of this bush is in Shankton lordship, on the East side of the Gartree-road from Medburn to Leicester, nearly where it is intersected by the road from Melton to Harborough.

The Gartree (or Gore Tree) was an oak tree that marked the ancient meeting place or 'moot' for the elders of the Gartree Hundred. Local landowners would gather around the Gartree oak to record their goods and make trading deals. We know from records that between at least 1458 and 1750, the hundred courts met at the oak until they decided to move them to the Bull's Head in Tur Langton – the nearest convenient inn to

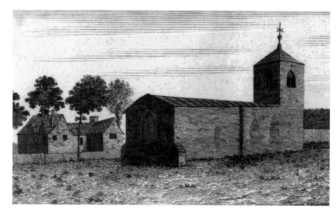

Newton Harcourt, the church of St Luke, formerly a chapel of ease.

Newton Harcourt, the church of St Luke, photographed in spring 2014.

the ancient meeting place. This primitive, open-air court was chosen so that the sheriff could make fair judgement without the influence of spirits who haunted buildings. Nichols quotes a very precise local description of this ancient meeting place:

> Gartre Bush (as it is called, for the thorn-bush was down long before my memory) consists of four venerable wide-spreading decayed elm-trees, and one large elm-stump; which, by their decayed appearance,will probably in a short time be no more visible. The whole forms three sides of a tolerably regular square; [...] About half way down the agger, on the North edge of it, stand two polled ash-trees; and on the South edge another tree of the fame kind. These have evidently been planted long since the elms were. In the centre of the square, as I am informed, was a white thorn-bush (long since decayed), under or round which the court-business was transacted.

The church at Shangton, mainly dating to the fourteenth century and dedicated to St Nicholas, lies outside the present settlement but overlooks, to the south, the original abandoned village. Local legend tells that a candle was lit in the small windows at the west end of the church to guide the villagers to worship on dark winter evenings.

In Nichols' time, the church was said to be surrounded by fir trees that had been planted by the rector, Charles Markham, around 1770. Tall fir trees still stand in the precincts of the building today. Three are shown in the engraving by Barak Longmate in 1793, where they appear to have grown higher than the top of the church's small bell tower.

Stretton Magna

Now isolated and neglected, the church of St Giles stands overlooking the earthworks of the deserted medieval village it once served. The village was enclosed and depopulated between 1640 and 1670, after which the church fell into a near ruinous state, although it was rebuilt in 1838. Several windows and the south porch and doorway date from this time. The earliest part of the structure is twelfth century, and the tower is mainly fifteenth century.

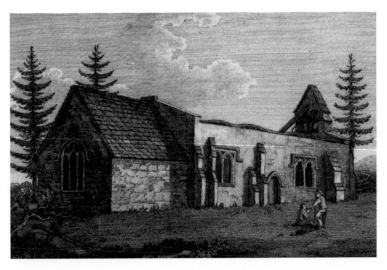

Shangton, the church of St Nicholas standing close to the site of the old village.

Shangton, the church of St Nicholas as viewed
through the Victorian churchyard gateway
in 2014.

The most familiar view of St Giles is from the nearby Roman Gartree Road looking
south, but the illustrator and engraver, William Prattent, chose the opposite perspective.
The churchyard, with several rows of headstones all facing east, is also to the south of
the church and was in use as recently as the twentieth century. The church is now
boarded up; inaccessible and in a dangerous condition.

One of the many colourful footnotes (more village gossip than objective history)
that Nichols included in his work can be found beneath his pedigree of the Hewett
family of Stretton Magna, and relates to George Villiers Hewett, younger brother of
William Hewett, a former High Sheriff of Leicestershire:

This gentleman, captain of a company in the Leicestershire regiment of volunteers
under the command of the late marquis of Granby in the rebellion of 1745, resided
long in Leicester. He was in his earlier life considered the polite and accomplished
gentleman in the bail and assembly rooms; and his mind was taught with learning
and good sense. In the decline of life, he was considered by the young as a whimsical
old man; his habits being original, his dress, peculiar, and his deportment bordering
upon rudeness. He was a constant attendant at church, sat among the aldermen, but
looked very unlike one. He wore shoe-strings (then little used), red garters below his
breeches' knees; a scarlet coat, retaining the fashion of his youth, a queue wig (the
aldermen then wore large wigs full-bottomed); and a large black ribbon tied round
his neck. In the church he never kneeled, disliked singing, and shewed not a token of
complacence to those about him. As he came into the church he went out, without a
nod or a bend, and always before the congregation, while the clerk was giving out the
Psalm. He lived a bachelor till he was upwards of seventy years of age, and then took
a wife of the age of 25.

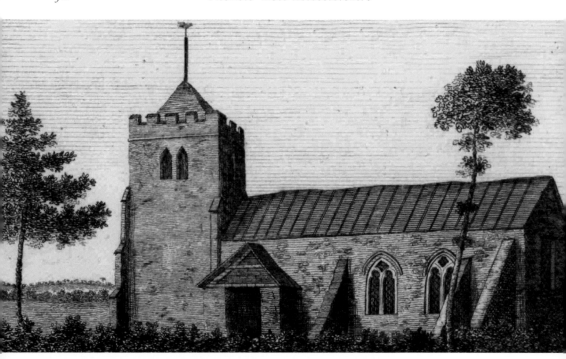

Stretton Magna, the church of St Giles, standing within its deserted medieval village.

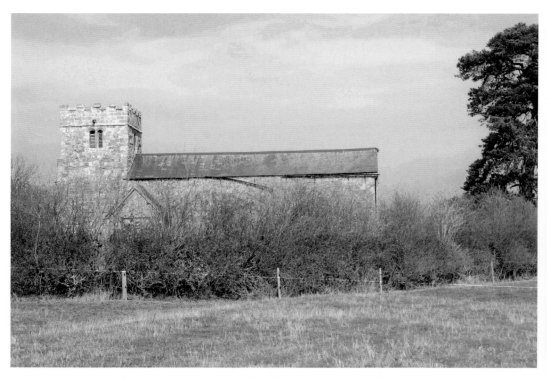

Stretton Magna, the church of St Giles. The building is now inaccessible and unsafe.

4

East Goscote

Ashby Folville

The detail in the description of the monument in Ashby Folville parish church to Ralph Woodford suggests that Nichols wrote it himself and had therefore visited the church, but the figure incised on the slab, as Nichols reported it, had no face:

> This figure, by the delicacy of the hand, the palm of which is turned outwards, and the very small fingers, is evidently that of a lady, apparently headless; nor is there on the stone the least vestige of any thing ever having been engraved above the neck.

The image is unique in Leicestershire and Rutland in being the only shrouded figure on a slab. It is, despite Nichols' opinion, the figure of a male. The figure is now complete, and debate continues as to why it was incomplete when Nichols visited Ashby Folville. F. A. Greenhill in his *Incised Slabs of Leicestershire and Rutland* suggests that the design was first marked out on the slab with some form of black pigment, and that because all the lines were filled up level with pitch after engraving, no one noticed that the face had not been cut.

However, a study of his will and of the family's cartulary indicates that Ralph Woodford had a strong sense of his family's history, and that he was aware of how to use religious symbolism, heraldry and imagery to reinforce his family's hold and influence on his estates. It seems very unlikely that this man, who also served as Sheriff of Leicester and Warwick, and who paid handsomely for this monument, placed in an important area of the church, would have accepted a memorial without a face.

The images of Ashby Folville, including Ralph Woodford's tomb, were drawn and engraved by James Peller Malcolm in 1793.

Beeby

As Nichols notes, the village of Beeby is located only 5 miles from Leicester. Today, the sprawling suburbs of the city can be seen from the tower of the church of All Saints. Nichols also records the settlement's great antiquity by quoting from a confirmation grant of Witlaff, king of the Mercians in around AD 830.

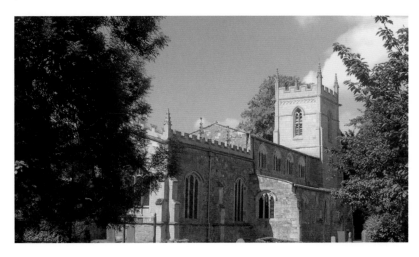

Ashby
Folville,
the church
of St Mary,
photographed
in June 2007.

The church was without a spire when engraver John Pridden visited on 17 July 1791, and in one of Nichols' characteristic footnotes, he recounts a local story:

> There is a tradition, for the truth of which we cannot vouch, that two brothers, who had engaged to build the steeple, when had reared it to the present height, quarrelled and that one pushed the other from the scaffold, who was killed on the spot; which was the occasion of its not being finished. On this subject the following coarse verse prevails:
> > 'Beby Tub was to have been a spire.
> > Two brothers fought, and broke their necks;
> > and so 'twas built no higher.'
> Tradition farther says that these brothers built the elegant spire of Queniborough in this neighbourhood.

The church is now redundant and is maintained by the Churches Conservation Trust. Pevsner, considering the building in its restored condition (which included a brick-built chancel and a granite porch), describes the building as 'an unfortunate church'.

Pridden's sketch also shows, in the foreground, a small stone and pitched roof building which stands over an ancient spring. The present structure, which is Grade II listed, is a stepped pyramid of stone with a cast-iron pump on the roadside. It was built in 1855 at a cost of £50, and was refurbished in 1953 to mark the Coronation of Her Majesty Queen Elizabeth II. At one time, a low cast-iron railing surrounded the pump but this is no longer present. On the side of the present structure is a faded inscription:

> In summer's heat and winter's cold
> One constant temperature I hold;
> When brooks, and wells and rivers run dry
> I always yield a good supply.
> My neighbours say (I'm often told)
> I'm more than worth my weight in gold.

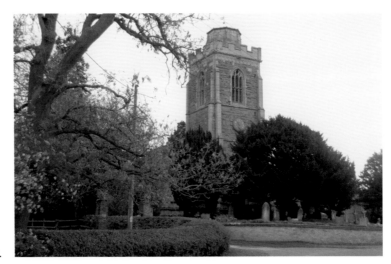

Beeby, the church
of All Saints,
now redundant
and in the care
of the Churches
Conservation Trust.

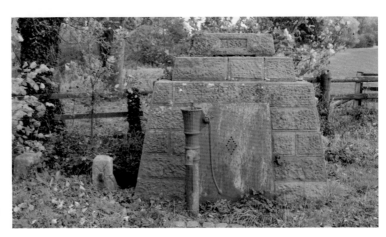

Beeby, the village
well, refurbished
in 1953 to mark
the coronation of
Her Majesty Queen
Elizabeth II.

Cossington Rectory

This building, magnificent in Nichols' time and still stunning today, possibly owes its survival to its secluded location; almost hidden by All Saints' parish church, protected from prying eyes and at a distance from the passing traffic on the main road through the village. As the eighteenth-century engraving shows, it is an integration of separate buildings, the right-hand side being part of a structure earlier than the rest of the building which dates to the fifteenth or possibly early sixteenth century. Over the past 200 years, several incumbents of Cossington have left their mark by making changes and additions to the fabric.

Launde Abbey

John Nichols uses a Shakespearean quotation from *Henry VI* (Act III, Scene I) to explain the origins of the name of the Launde estate: 'For through this laund anon the deer will come'. The origin is Middle English, meaning a glade or an open space

Cossington rectory. The engraving emphasises the earliest parts of the building.

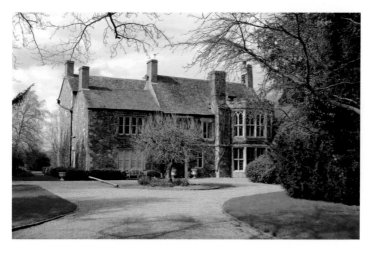

Cossington rectory in April 2012, secluded in the shadow of the parish church.

between woods, and is related to the old French word *lande* meaning a heath, moor, barren land or clearing. Chaucer used it too in the phrase 'In a laund upon an hill of flowers'. By Nichols' time, the word also meant an area where the grass was kept cut, from which the modern word lawn has derived. Today, the description is totally appropriate, but in the past it may have had associations with its geographical location near the Royal Forest. Near to Launde is Sauvey Castle, which for some time served as the administrative centre for the forest.

Launde Abbey was never an abbey. It was an Augustinian priory. Only the chancel of the original priory church and a section of the transept arch survive from the pre-Dissolution period, and these date to as early as 1125. The present building was constructed by the family of Thomas Cromwell, although much altered over the intervening centuries.

Today, Launde Abbey is a residential retreat house and conference centre serving the dioceses of Leicester and Peterborough. It underwent major refurbishment in 2009 following a successful appeal by the Diocese of Leicester which raised £1 million.

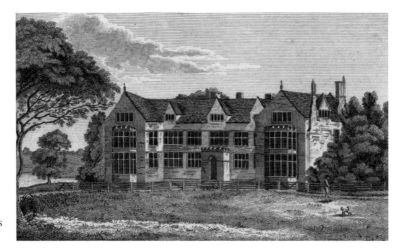

Launde Abbey.
Parts of the
building date to as
early as 1125.

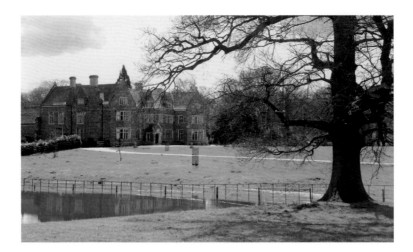

Launde Abbey
in April 2012,
renovated and
refurbished by
the Diocese of
Leicester.

Queniborough

The church, with its 'very handsome, tapering, crocketed spire of wrought stone' was sketched by John Pridden in 1796 at just after 11 a.m. (if Cary's engraving is accurate, judging by the time on the clock and the shadows cast by the sun from the east).

Nichols includes a lengthy debate about the economics of land ownership, as at the time he was assembling his material, Queniborough was undergoing enclosure.

Unusually for a Leicestershire village, Queniborough in the early eighteenth century was centred on one wide long street, which at that time contained about ninety houses, with the church and the inns at the centre. Nichols comments that this is more reminiscent of a grand plan for a large town rather than a small village.

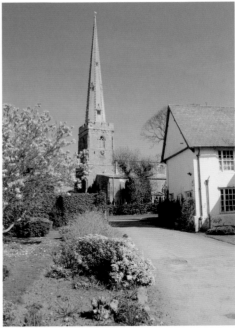

Left: Queniborough, the church of St Mary, engraved by John Pridden.

Right: Queniborough, the church of St Mary in April 2012.

Ragdale Hall

The old hall was demolished in 1958, and in Pevsner's view was 'one of the finest sixteenth-century to seventeenth-century houses in the country ... which should never have been allowed to decay and disappear'.

Its former location can be confirmed by the tall cross in the adjacent churchyard in James Peller Malcolm's engraving. It is still standing in the same position today. The scene has since been a favourite of local topographical artists.

The old hall was built by Sir John Shirley as a falconry lodge and enlarged by successive generations. It fell out of use and was converted to farm accommodation when the 'new hall' (now a health hydro) was constructed in 1785. The occupiers had little understanding of the architectural significance of the old hall, and the owner was seldom present, resulting in a steady decline in the structure and its ultimate demolition.

Skeffington

The village of Skeffington has benefitted greatly by the fact that the main route between Leicester and Peterborough has bypassed the settlement for centuries. In the twenty-first century, it is still a village of narrow winding paths and of a remarkable array of fine buildings.

The church is dedicated to St Thomas Becket, and the chancel was rebuilt in 1860. There is evidence of a church in the village in the thirteenth century.

Ragdale Hall and the church of All Saints, engraved by James Peller Malcolm in 1792.

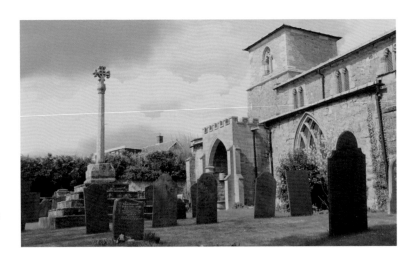

Ragdale, the church of All Saints in 2012. The cross is still in the same position. A low retaining wall is all that remains of the old hall.

The oldest part of the present building is the nave which dates to around the thirteenth century.

Skeffington Hall, which is situated to the immediate east of the church, is a house with a complex architectural history. Dating from the fifteenth century, the gables were added in Nichols' time, and there have been numerous alterations since then. The earliest part of the hall, nearest the church, was completed around 1460 using stone brought from a house in Keythorpe, near Tugby. The house as it is today was completed between 1660 and 1680, except for the Victorian additions.

Tilton on the Hill

The origins of Tilton are to be found in the principal routes of Saxon Leicestershire, being situated at the intersection of paths between Leicester, Oakham, Market Harborough and Melton Mowbray.

Skeffington Hall,
photographed in
October 2014.

The village 'on the hill' stands around 700 feet above sea level. The village website claims that in an easterly direction there is no higher place until the town of Chelybinsk, infamous for its secret nuclear research on the edge of Siberia some 2,250 miles distant.

The parish church of St Peter is actually in the former parish of Halstead, which merged with Tilton in 1935. The first record of a religious establishment in the village is a reference in the Domesday Book to the existence of a priest in Tilton. Most of the current church dates to the thirteenth and fourteenth centuries. In the churchyard is a cross base and shaft from the thirteenth century standing nearly 8 feet tall, which is in its original position.

Twyford

The name is derived from the two ancient fords in the village over the Gaddesby Brook, referred to by Nichols as the River Eye. The roads and the watercourse actually cross each other at three points: the main road from Melton Mowbray, the Main Street and the Burrough Road. Nichols dated the stone bridge on the Melton Road to 1783.

Twyford was never a wealthy living. It was united with the vicarage of Hungarton in 1732. Revd George Ashby comments in Nichols that:

> The churches used to be served for £13 apiece; but I could not find a curate that would stay for £60; so that I was glad to run away myself, and leave them.

He also comments, no doubt from his own visit to the church, that:

> In the nave is a poor-man's box, with three hasps and staples for three locks. On it is the date '1618.' The clerk told me, he never remembered but one solitary half-crown being put into it; and that by a gentleman who, many years ago, accompanied Mr Ashby of Thorpe to this church for public worship.

Given that Luigi Galvani did not publish his discovery that electricity was the medium by which nerve cells passed signals to the muscles in the body until 1791,

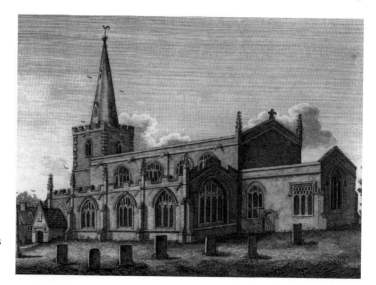

Tilton on the Hill. The church of St Peter stands around 700 feet above sea level.

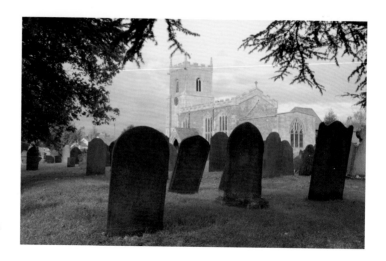

Twyford, the church of St Andrew, with restoration work from 1849, 1889 and 1980.

it is interesting that Nichols mentions the case of Mrs. Mary Beaumont of High Twyford who was cured of an obstinate paralytic disorder by electricity in 1760.

Ulverscroft Priory

The priory was founded by Robert de Beaumont in 1134 as a sanctuary for hermits of the Augustinian Order. Originally probably constructed of wood, it was rebuilt in stone from the Charnwood Forest in the thirteenth century.

Ulverscroft was never a rich or large priory. In 1532, nine canons and a prior were living there. Three years later, its annual income was only £83. As well as the canons, there were also twenty yeoman servants, fourteen children for the chapel and three women for the dairy. It was scheduled to be dissolved, but its good reputation allowed it to continue for a further four years after the payment of a fine. It was finally dissolved

on 15 September 1539, and the buildings passed to the Earl of Rutland, then through a number of owners. It never seems to have been converted into a tenanted farm, and the priory buildings were never cleared but mostly reused.

Ruins of the tower and the priory church remain. The prior's lodging and refectory are now incorporated into a farmhouse built on the site. The door of the priory is now in nearby Thornton church. The site was acquired by Sir William Lindsay Everard in 1927, who funded renovation work by William and Margaret Keay of Gaulby carried out over five summers between 1928 and 1933.

Ulverscroft Priory. A romantic interpretation of the ruins.

Ulverscroft Priory, the 'most conspicuous monastic ruin in Leicestershire' according to Nikolaus Pevsner.

West Goscote

Ashby de la Zouch Castle

The description in Nichols of Ashby de la Zouch and its castle was published only fifteen years before Sir Walter Scott visited the town at the invitation of his friend Sir George Beaumont of nearby Coleorton Hall.

In the summer of 1819, Beaumont took Scott to the nearby village of Smisby where they climbed a watchtower at the Manor House from which a dramatic view of Ashby Castle could be seen. Beaumont also pointed out a field that he said had been the traditional scene of tournaments in the medieval period. Later that year, Scott published *Ivanhoe* with the key confrontation between good and evil set in precisely this location. If Scott did climb the watchtower, then it was a brave endeavour. While he was working on the novel, he was too ill to hold a pen and the work was committed to paper through an amanuensis. Ironically, as Ashby was to become famous as a

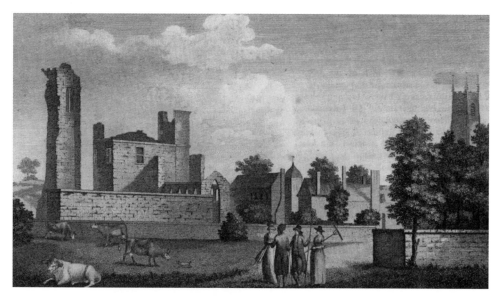

Ashby Castle. The engraving by John Throsby.

spa resort, in his youth Scott sought the rejuvenating powers of spa water to heal his lameness caused by childhood Polio. However, he found those cleansing waters in Bath, not in Ashby. By 1822, *Ivanhoe* had become a bestseller and the Ivanhoe Baths were constructed – a project which would change the nature of the town for ever.

Following the slighting of the castle in 1649 by the Parliamentarians (the castle was deliberately made uninhabitable by destroying a complete wall of each building) the Hastings family moved their attentions to Donington Park. Gradually, the structure of the castle continued to decay.

Although the first Marquess of Hastings (1754–1826) initiated some preservation work, it was the success of *Ivanhoe* that brought about a turning point in the history of Ashby and its castle. After a century or more of neglect, people began to notice it again.

Coleorton Church

At the heart of what was to become the Leicestershire and South Derbyshire coalfield, Nichols informs us that Coleorton also derived its name from the mineral that was have an overbearing influence on the landscape and the people of the area for many generations:

> Antiently called Ovretone, takes its name of distinction from the pit-coals scattered on the moor, which for more than two centuries have been dug here in great abundance, to the great profit of the lords of the soil.

During the Civil War, Cromwell's forces had based themselves on the site of Coleorton Hall, a location strategically important as the Royalists held Ashby Castle 2 miles away. Attacks on Ashby continued for at least two years, with the Royalist counter-attacking from time to time.

The parish church of St Mary the Virgin stands next to the present Coleorton Hall, but is much older. Construction of the hall by George Howland Beaumont commenced in 1804, the year in which Nichols' West Goscote volume was published. At that time, the church was alone in an open landscape:

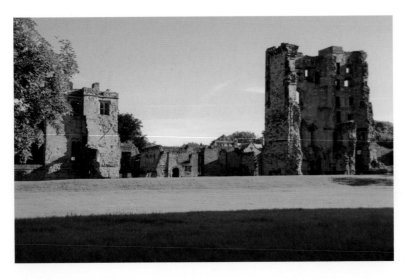

Ashby Castle, photographed in July 2012.

The taper spire emerging from trees (for a few trees do remain in the village, though they are gone from the park) is a beautiful object to the circumjacent country.

After the nationalisation of the coal industry in 1948, the hall became the regional headquarters of the National Coal Board. In 1994, the industry was dispersed into private companies, and Coleorton Hall was converted into residential accommodation.

Garendon Hall and Estate

Founded in the wild countryside of the Charnwood Forest in 1133 by Robert Earl of Leicester, Garendon was one of the earliest Cistercian abbeys in England. Its name derives from the Saxon *Gaerwald's Dun*, which was a settlement that survived for centuries before being obliterated when the abbey was constructed, and its lands were laid out. This small community is noted in the Leicestershire Survey as *Geroldon* just eight years before the monks arrived, which suggest that the end of the settlement was short and traumatic.

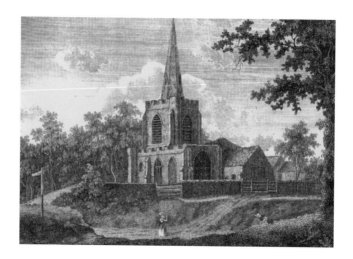

Coleorton, the church of St Mary the Virgin.

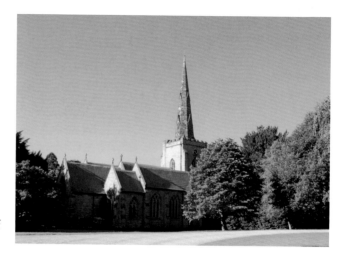

Coleorton, the church of St Mary the Virgin, now part of a private residential estate.

Over time the abbey grew wealthy (its income being derived from agriculture and sheep farming), but the reputation of the monks became tarnished with reports of incidents of indiscipline and even violence between the lay brothers and the monks.

At the Dissolution in 1536, the monastery was in a poor state. Within a short time the abbey church was demolished. The remaining buildings were left to decay to complete ruin. The estate and buildings were granted to the Earl of Rutland for £2,356 5s 10d, and it was he who built the first house at Garendon. In 1632, the estate passed as a dowry to the Dukes of Buckingham.

The fortunes of Garendon changed again in 1684 when Sir Ambrose Phillipps, a successful London lawyer of the Middle Temple and King's Sargeant to James II, purchased the estate for £28,000 – over £4 million pounds in today's currency.

Sir Ambrose died just seven years later, and his son William inherited Garendon and extended it. The estate grew and provided the family with enough wealth and status to enable Ambrose, his eldest son, to go on the Grand Tour of France and Italy after he had inherited Garendon in 1729.

The Grand Tour provided Ambrose with far-reaching ideas and ambitions for Garendon. Reflecting what he had learned, particularly regarding the architecture of Rome, he created a landscape designed to proclaim his learning and culture, and provided a new vista from his house. He had canals cut and avenues of trees planted, and then turned his attention to the buildings.

The house was located on ground below the surrounding ridges on the southern and eastern estate boundaries. Ambrose used this feature to great advantage, constructing a new landscape with several unique, classically inspired structures to draw the eye.

He also designed the addition of the grand Palladian south front of the hall, though the work was completed after his death. The estate and house then passed to Ambrose's brother Samuel, and it was he who took on the rebuilding of Garendon Hall to the existing Palladian designs. This created an elegant eleven-bay house fronted by a full-height portico with Corinthian columns and an open, triangular pediment. Inside, the great hall was said to be particularly fine and not unlike the vestibule of the Doge's Palace in Venice. On each side were two gateways designed by Inigo Jones, of which one has survived.

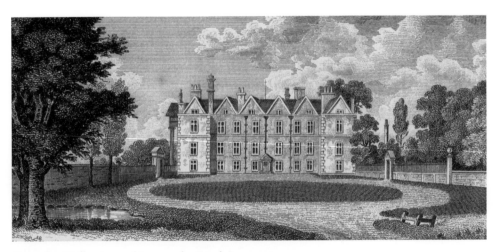

Garendon Hall, engraved in 1795 by Barak Longmate.

As Samuel was the last of the male Phillipps line, on his death in 1796 the estate passed to his cousin, Thomas March, who adopted the surname Phillipps. Thomas married Susan De Lisle of an old family from the Isle of Wight. Their son, Charles March Phillipps (1779–1862) adopted the De Lisle crest and arms.

It was his son, Ambrose Lisle March Phillipps de Lisle, who commissioned Edward Welby Pugin, the son of the more famous Augustus Pugin, to extend the hall. Ambrose had also converted to Catholicism, and this was to influence his approach to the layout of the estate and the buildings within it. Ambrose chose Pugin because of their shared Catholic faith, and he gave the architect considerable funds to enable his designs to become reality. But the result was unsatisfactory in terms of scale and the unhappy merger of different styles of architecture.

Financial stringencies following the deaths of Ambrose in 1878 and his son in 1883 prompted a rationalisation of the estate. The heir, Everard March Phillipps de Lisle and his family, moved away from Garendon to nearby Grace Dieu.

By 1907, the family's finances had improved and Edward, with his wife Mary and family, returned to Garendon, a move that, according to local newspaper reports, had popular support. The *Coalville Guardian* reported the speeches, music and celebrations that were enjoyed by crowds numbering around 6,000.

The arrival of troops during the Second World War was to herald the end of the family's residence at Garendon. Part of the estate had been used prior to the First World War as a training camp for the Leicestershire Yeomanry and the Territorial Army, with more than 17,000 troops passing through the estate's private railway station at Snell's Nook in 1911.

After the Second World War, the damage and destruction that had occurred led to its demolition. The heir to the estate, Ambrose (born 1894), lived at Grace Dieu but returned to his ancestral home in 1955. His death in September 1963 prompted high death duties, and all around, modern development, both industrial and residential, was encroaching. Eventually, the hall was finally abandoned. In May 1964, it was demolished by the M1 motorway contractors, McAlpine. The rubble was used as foundation for the road.

Remnants of Ambrose Phillipps' Arcadian landscape survive in the triumphal arch and temple of Venus, but in 2014, English Heritage deemed both to be at risk.

Ravenstone Almshouses

Although less than 3 miles from the centre of Coalville, the Ravenstone Almshouses are in a rural country setting. They were commissioned by John and Rebecca Wilkins of Ravenstone Hall in memory of their only child, Francis, who died aged twenty-one in 1711. The buildings were constructed shortly after Rebecca's death in 1718.

Intended to care for thirty 'poor women', initially there were only sufficient funds for twenty-five women and two servants, but in 1784, a further two wings were added and further extensions were made around 1860.

Preference was given to women residing in Ravenstone, Swannington and Coleorton. Each resident was to receive 3s 6d per week and wear a gown of grey serge. Material for renewal of the gown was given annually. Two wagon loads of coal were given to each annually. The residents had to attend the chapel for prayers each morning, which were conducted by the resident chaplain. The warden still lives on site, and weekly

A still from rare film footage of Garendon Hall on fire during its demolition in 1964.

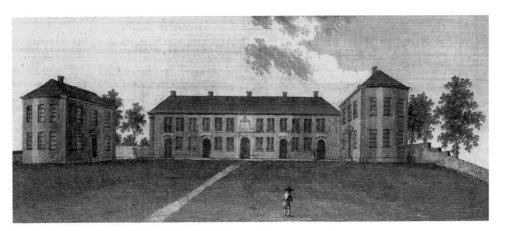

Ravenstone Almshouses, as engraved in 1795.

services are still held in the chapel. The entire complex of buildings is now Grade II listed. The accommodation was modernised in the 1960s to provide centrally heated, self-contained flats on one level, either on the ground floor or first floor.

HRH Princess Alexandra visited the almshouses in May 2012 as part of the 300th anniversary celebrations.

Staunton Harold

The parish church of the Holy Trinity at Staunton Harold is a rare example of one founded during the Commonwealth period. Sir Robert Shirley commissioned it in 1653, but did not survive to see it completed. He died in 1656, imprisoned in the Tower of London. The church is now owned by the National Trust.

The Staunton Harold estate has survived many twists and turns of fortune in its long history. For centuries it was the seat of the Shirley family, until the middle of

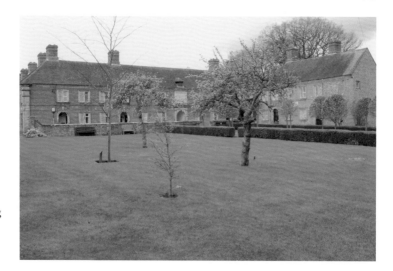

Ravenstone Almshouses, serving its original purpose and thriving in May 2012.

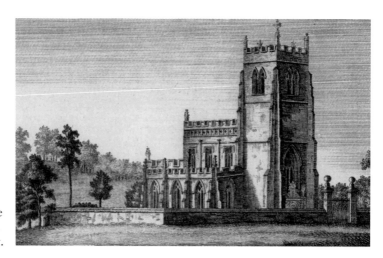

Staunton Harold. The church is now owned by the National Trust.

the twentieth century when it was sold to a demolition company but rescued by the Leonard Cheshire Foundation, who used it as a Cheshire home and hospice until 2002. Since 2003, the hall with its large estate extending over more than 2,000 acres has returned to private ownership. Grade I listed, the hall with eighty-three rooms accommodates three generations of the family, who now own the estate and have created a variety of business enterprises.

Swithland Hall

Completed in 1834, after fire had destroyed the original hall on an adjoining site, Swithland Hall, with its Greek columns and first-floor oriel, seems strangely out of keeping in the English landscape. It was designed by James Pennethorne for G. J. Danvers-Butler – later the Earl of Lanesborough. The varied use of granite, local slate and brick is disguised by the painted stucco finish.

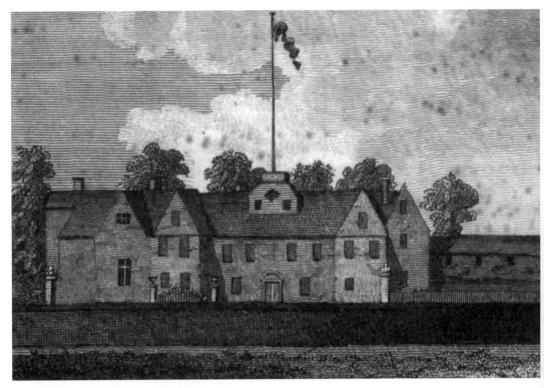

Swithland Hall, as engraved by John Throsby.

Swithland Hall. The new building of 1834, photographed in May 2012.

6

Guthlaxton

Arnesby

Now much worn due to exposure to the elements, high up above the east window of the church is a statue of the patron saint, St Peter, with his right hand lifted as if blessing and a key in his left hand.

Nichols notes another niche, 'larger and more curious', above the west door of the tower, which, according to local people, once contained a statue demolished during the Civil Wars.

The view, as sketched and engraved by Thomas Prattent in 1792, is now obscured by a profusion of trees and bushes, and the church was heavily restored in 1868.

Ashby Magna

Nichols gained much information for his history from the rectors and churchwardens of Leicestershire, including notable activities of some parishioners. He and his engravers and illustrators also received hospitality from the clergy when visiting a village or church. Long after Nichols' time in Ashby Magna, during the Second World War, the same spirit

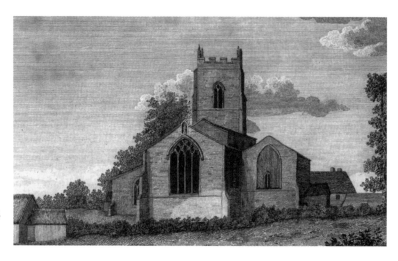

Arnesby, the church of St Peter, engraved by Thomas Prattent.

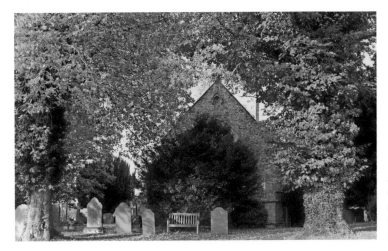

Arnesby, the church of St Peter. The view of the east window is now obscured by trees.

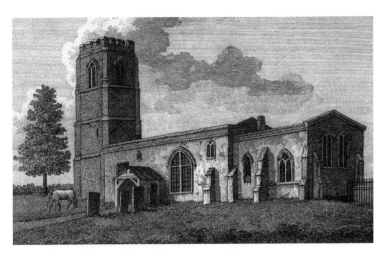

Ashby Magna, the church of St Mary, drawn by Barak Longmate.

of hospitality continued when it became home to the artist Erlund Hudson who lived with her brother, Paige, the vicar of Ashby Magna, his wife, Susan, and their three children.

The rectory had large outlying barns where the local farmers' wives worked at trestle tables to prepare dried herbs and flowers that were sent to hospitals for medicinal purposes. Hudson sketched this scene, as well as the large canteens in Leicester where she helped to pack supplies for prisoners of war.

After the war, Hudson designed costumes and scenery for Sadler's Wells and Ballet Rambert. In 2007, the Imperial War Museum held a party in her honour. She died in 2011.

Bruntingthorpe

The church of St Mary was once in the heart of the village, but is now in open countryside, and it is not the building as sketched by Thomas Prattent in 1792. In 1873, the earlier building was demolished to its footings and a new church constructed

on the same site by William Smith, a Scottish architect who followed his father and grandfather in a church-building career.

The illustration of the old rectory by Barak Longmate, made in 1793, is dedicated by Nichols to the late Revd Sambrooke Nicholas Russell, rector of Bruntingthorpe until his death on 29 November 1795. Pevsner suggests that a painting on the north wall of the chancel of the present church, depicting the Descent from the Cross, could be by Russell. If so, he is included in it as a self-portrait.

Frolesworth

It seems likely that the text for this section of Nichols' history was written by someone close to the Frolesworth community because of the wealth of very local knowledge. The benevolence of John Smith, who was born in the village and rose to national prominence, is celebrated:

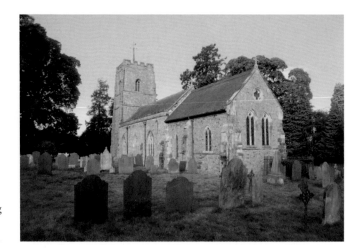

Ashby Magna, the church of St Mary in 2013. Among other refurbishments, the chancel has been re-roofed.

Bruntingthorpe rectory. A romantic drawing by Barak Longmate in 1793.

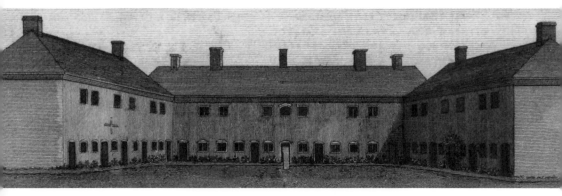

Above: Frolesworth Hospital. In this engraving, the buildings look prison-like and lack character.

Left: Frolesworth Hospital. After several periods of restoration and refurbishment, the hospital is now a welcoming place, although the quadrangle garden is much overgrown.

> This gentleman was much attached to his native village; but the house he lived in has nothing remarkable about it, except its plain and humble appearance, which would bespeak it to have been always the residence of a farmer.

Smith became Chief Baron of the Exchequer in Scotland and one of the Barons of the Exchequer in England. He provided in his will for the building and maintenance of almshouses for fourteen residents in the village of his birth. The buildings have survived and are still thriving. There are now sixteen cottages, all with central heating. In 2001, a new village hall was added to the rear of the premises, which is somewhat unsympathetic in its architectural features. Above the original entrance to the hospital is the motto of the Smith family: *vertuti non verba* – deeds not words.

Nichols includes a report from the *London Loyal News* of an illegal meeting of 'dippers' that took place in Frolesworth on 5 November 1682 marking the anniversary of the Gunpowder Plot. Dippers was a descriptive name for religious groups that believed in baptism by immersion. Given the presence of many Baptist communities in the area, notably in Sutton-in-the-Elms and Arnesby, one presumes that this group was also of the Baptist faith. The newspaper reported:

The minister of Frolesworth having notice of it, presently after morning sermon, ordered the constable, with some help, to go and suppress them, which he did; but could not enter the house to take them at their exercise, by reason of a court-yard which was before the house, and the door of it bolted; but yet he saw them all cleared, and 'tis not questioned if they go on they may pay for it at last. Their holder-forth (ie: the preacher) is not known from the rest; for they being dippers (as that county phrase is), they take it by turns, or as the inward man moves them.

Knaptoft

Despite the diligent work of the Friends of Knaptoft, the ruins of the church are desolate and overgrown and dominated by an ugly farm building on the site of the earlier manor house. Jacob Schnebbelie's sketch, made on 15 September 1791, just five months before his death, shows more extensive remains than exist today. It is said that the building was partially destroyed by Cromwell's troops moving north after the battle of Naseby. Nichols offers an informative comment relating to the geography of the parish:

At Knaptoft, which is situated nearly in the centre of the kingdom, is an extraordinary instance of natural curiosity. Three springs originate, or take their rise, in this lordship,

Knaptoft church ruins. Although local groups maintain the ruins and open-air services are held in the summer, the church remains appear unkempt in this photograph taken in October 2014.

or its environs, and proceed to three rivers, which empty themselves into the sea at three different parts of this kingdom.

The first takes its direction for, or is one of the heads of, the Soar, which, running North-west by Leicester, directs its course Northways for the Trent, which proceeds to the Humber, and falls into the sea at or near Partington in Yorkshire. The next passes to a small but rather rapid stream, called the Swift, which runs Southwest by Lutterworth, after which it joins the Avon, which proceeds' to the Severn, and empties itself into the British Channel. The last takes its course for the Welland, which runs South-west by Harborough, and passes into the Nene or Nine, which falls into the German Ocean near Lynn in Norfolk.

Shearsby

For would-be Saxon scholars, the third bell in the tower of St Mary Magdalene, Shearsby, may be of help because, according to Nichols, it bears the alphabet in Saxon.

The tower is incomplete and has stayed in this condition since 1789, its architecture suggesting that an octagonal spire was planned. Approaching the village from Bruntingthorpe along Back Lane, the church appears standing high above its settlement. Around half a mile from the village a spring was situated:

> It is an uncovered round pit, at which no cattle will drink. It is about ten or twelve yards in circumference; and in August 1805 was about a yard and a half deep, being then full. Its taste is very saline and brackish, without any acidity; and in very dry seasons is probably more salt than it was after the last wet summer. The son of an inhabitant of Shearsby some time since drank the water, and bathed in it for a scorbutic complaint and found great benefit from it: and there is little doubt that this spring, if properly taken care of, and secured by a building over it, and the recommendation of a few MDs, might be as beneficial in many disorders.

It was regarded as a holy well, and converted into a spa in the early nineteenth century. Analysis of the mineral content revealed the major constituents to be sodium sulphate and sodium chloride, but by 1855 it had fallen from favour. Today, it is the location of the Shearsby Bath Hotel.

Willoughby Waterlees

Formerly Willoughby-on-the-Wolds, the modern name reflects the copious springs that lie near the surface across the village. The sketches of the church are by Thomas Prattent, who visited in 1792, and Barak Longmate, in June 1795. The church, dedicated to St Mary, was severely restored in 1875.

Of all the settlements in Guthlaxton, Willoughby Waterlees probably has more cottages and other buildings that can be dated to Nichols' time than any other.

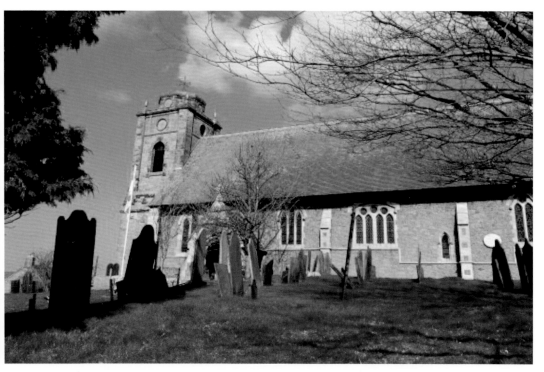

Shearsby, the church of St Mary Magdalene, photographed in January 2014.

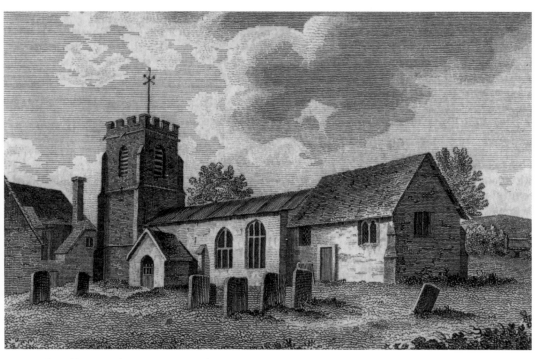

Willoughby Waterlees, the church of St Mary. This view is now obscured by trees and vegetation.

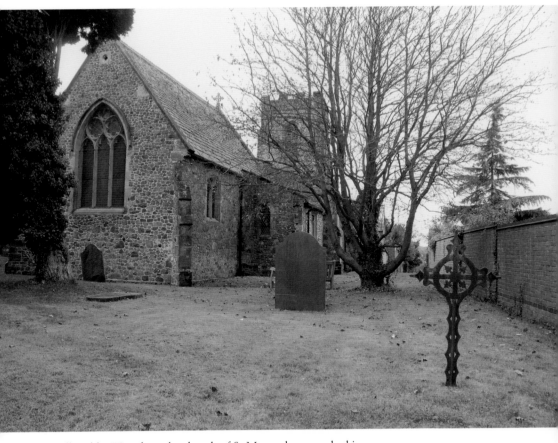

Willoughby Waterlees, the church of St Mary, photographed in 2014.

7

Sparkenhoe

Appleby Magna Moat House

At a small distance Eastward from the church stood the antient mansion of the Applebys, now called The Moat-House, from being surrounded by a moat, at present chiefly choaked up …. The house is chiefly built with the timber of a much older structure; though several of the old chimney-stacks yet remain entire. There is no painted glass; nor has any remained within memory of the present occupiers, who have lived therein more than half a century.

The Moat House at Appleby Magna is a remarkable survival, perhaps owing to its secluded setting. In Pevsner's words, it is 'eminently picturesque'. W. G. Hoskins described this structure as, 'The best preserved mediaeval house on a moated site … One of the best examples of 'black and white' timber-framed houses in the county'.

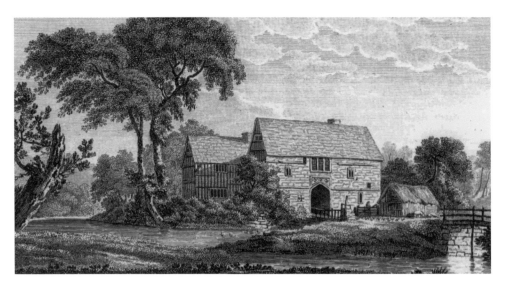

Appleby Magna Moat House.

The first moat house on this site was built soon after the Norman Conquest and was the home of the de Appleby family. Joyce de Appleby was burnt at the stake as a Protestant martyr and her husband, Sir George, was killed following the battle of Pinkie Cleugh in 1547. The son, George, sold the manor in the following year and later drowned. Only the gatehouse survives from this period. The timber-framed moat house of today was constructed during the sixteenth century, and retains many original features including carvings above the central fire place, which have prompted much debate among historians since Nichols' published engravings of them.

Nichols' contributors to this section record a local legend:

> Several years ago, one Joseph Green fell from the battlements of the church steeple, without receiving any injury. The same man, striking the centre of a cellar, had more than a thousand bricks fell upon him, and was very little hurt.

Barwell

The Leicestershire boot and shoe trade of the nineteenth century changed the character and size of Barwell from the rural settlement described by Nichols:

> In Barwell are many gardeners, who not only supply the Hinckley market with vegetables, but send also much of their produce to Leicester market.

However, in 2014, the parish church of St Mary still overlooks the countryside, and has been altered little for centuries. The adjoining parsonage was demolished in 1746 and rebuilt, and the church is now surrounded by modern residential development. Nichols recounts a fascinating story from the Civil War period relating to a Wych-oak tree on the Stapleton Lane, known locally as Captain Shenton's Tree. Shenton was an officer in Charles' army until after the Battle of Worcester in 1651 when he was forced to retreat:

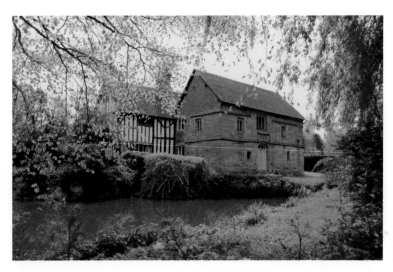

Appleby Magna Moat House in May 2012.

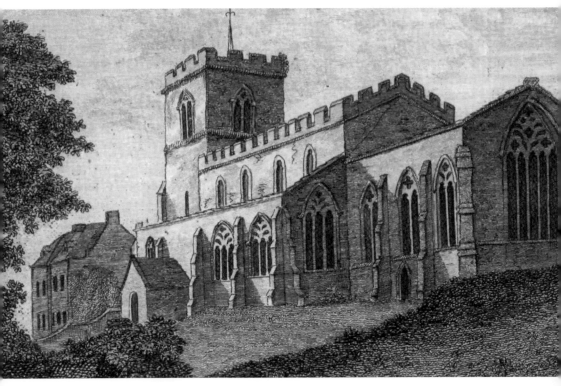

Barwell, the church of St Mary.

Captain Shenton came to his house at Barwell; and, gaining intelligence of a party being in quest of him, it is said that the portmanteaus and valuables were sunk in the moat which surrounded his house, and that the Captain had recourse to this tree, which was on his own estate, to secure himself from his enemies, whom, as they passed by, he heard say, that they would give so much for him dead or alive.

Although he had been close enough to hear his enemies discussing the price on his head, Shenton escaped capture and retained his estate. The tree was apparently held sacred for many years by the family because it had protected their ancestor.

Elmesthorpe

The church, dedicated to St Mary, was built in the thirteenth century, but had been in a ruinous condition since long before Nichols published his history, due to the depopulation of the village. It was partially rebuilt in 1869, when the railway brought a new population and more prosperity to the settlement. The new church occupies the east end of the building. The west end is still in ruins. All the memorials in the graveyard date to after the reconstruction.

It is claimed that Richard III stayed in the ruins for shelter on his march to Bosworth Field. The king and his officers rested inside the church. His soldiers camped outside.

Elmesthorpe, the church of St Mary, in ruins when engraved by John Pridden in 1792.

Elmesthorpe, the church of St Mary. The view of the north side showing the rebuilt east end.

Groby Old Hall

All that remains of the original Groby Castle is the castle mound, close to the present A6 dual carriageway. The earlier hall was probably built by the Ferrers family. It passed to the Greys by marriage after Sir Edward Grey married Elizabeth Ferrers around 1432.

The present red brick old hall was the former gatehouse, and is regarded as one of the earliest brick buildings in England, dating to the fifteenth century but incorporating much earlier structures within. It was the focus for a *Time Team* dig that was broadcast in 2011.

Groby Pool

Groby Pool is on the edge of the Charnwood Forest and is said to be the largest natural expanse of open water in Leicestershire. In 1956, it was listed as a Site of Special Scientific Interest because of its ecological importance.

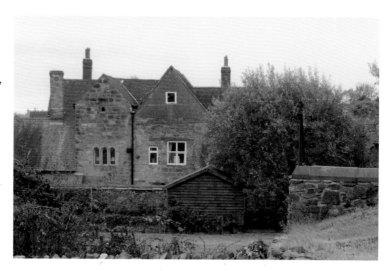

Above: Groby Old Hall as seen from the churchyard of the church of St Philip and St James, drawn by Barak Longmate.

Right: Groby Old Hall, the focus of a *Time Team* programme in 2011.

There is no mention of a lake in the Domesday Book, and its history is a matter for debate. It may have been created in the twelfth or thirteenth century by monks from Leicester Abbey who damned the Slate Brook. Another theory suggests Roman origins, perhaps caused by the extraction of clay for pottery. Old embankments were reinforced and raised in 1889 to prevent flooding of the nearby quarries, which raised the water to its present level. The pool is now owned by Hanson Quarry Products Europe Ltd, and managed in association with English Nature.

Kirby Mallory

The church of All Saints' has as its neighbour the Mallory Park racecourse, which was laid out partly on the site of Kirby Mallory Hall. The hall and adjacent land was used by the RAF during the Second World War as standby landing ground. This closed in 1947, and the hall was demolished five years later. The stable block and coach house remain.

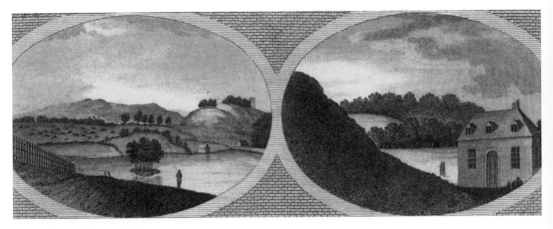

Groby Pool.

Groby Pool in October 2014. Since Nichols' time, the water level has risen considerably.

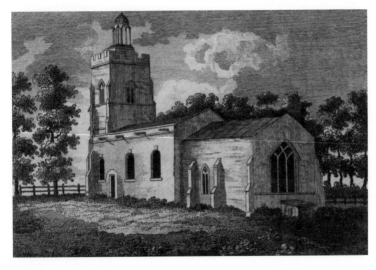

Kirby Mallory church engraved in 1790.

Lord Byron married into the Wentworth family who owned Kirby Mallory Hall. It is said that on his visits, he wrote beneath the shade of the Lebanon cedar tree that still stands in the racetrack grounds. Byron's daughter, Ada Augusta Lovelace, lived in the hall with her mother during her childhood, and an impressive monument to her stands in the corner of the churchyard. A mathematician and colleague of Charles Babbage; Lovelace died in 1815, the year which saw the completion of Nichols' history.

Kirby Muxloe Castle

A remarkable amount of information is known about the history of this impressive and picturesque fortified mansion. It was commissioned by William Hastings, the first Baron Hastings, and work commenced in 1480. It was never completed, owing to Hastings' execution in 1483 by Richard III, Duke of Gloucester. Parts of the castle were occupied by other members of the family, but by the sixteenth century the site was in ruins. The castle was sold by the Hastings family in 1630, and used as a farm. However, in 1911 the Ministry of Works took over the site and undertook repairs. It is now managed by English Heritage.

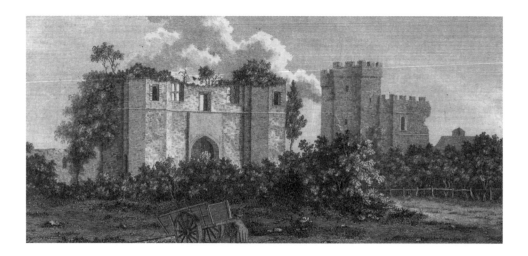

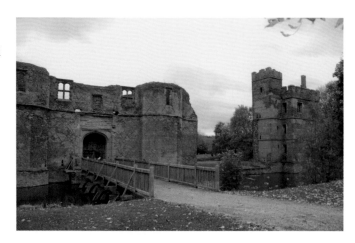

Above: Kirby Muxloe Castle. A building that was never completed, and for most of its time has been a ruin.

Right: Kirby Muxloe Castle in October 2014, now managed by English Heritage.

The engraver, James Peller Malcolm, visited the castle in 1792 and later recounted his impression of the building to Nichols:

> The situation of this castellated mansion is by no means commanding, nor was it rendered insecure by the neighbourhood of any eminence. All that remains of the most ancient part of the building is confined to a square embattled tower, connected with a second ... The upper part of the ruin is covered with bushes and ivy, which falls with beautiful luxuriance down the sides. The whole appears much reduced in height.

Nichols also prints a description on the state of the ruins as they appeared in 1809 by John Tailby of Slawston, which assists in reconstructing the history of the building.

Market Bosworth

Market Bosworth Hall is a grand structure due to its size and presence within its landscaped grounds, but it has been much altered over the past 200 years. However, these alterations have assured its survival and given it a role in the twentieth century as the Bosworth Hall Hotel.

The parkland of the present house was bought by Sir Wolstan Dixie, Lord Mayor of London, in 1589. The main house was built by his brother's descendant, Sir Beaumont Dixie, Second Baronet, who had inherited the estate in 1682. The Dixie family fortune

Market Bosworth Hall.

was lost in the nineteenth century, and the house and estate were sold in the 1880s to pay for gambling debts.

The Bosworth estate was bought by Charles Tollemache Scott in 1885, who made many changes, including replacing the cellar gates with doors from Newgate Prison in London. The doors are now the entrance to the Newgate bar. Tollemache Scott's daughter, Wenefryde, sold the Bosworth Hall estate in 1913, and in 1931 it was acquired by Leicestershire County Council and converted into a hospital.

In the 1980s, the hall was converted again – this time into a hotel with 192 en-suite bedrooms.

Shenton Hall

Shenton was purchased in 1625 by William Wollaston (1581–1666), and it was he who built the hall in the Jacobean style of the period. His initials and the date 1629 are carved in stone on the gatehouse frontage.

The last of the family to occupy the hall was Hubert Wollaston. He died in 1939, and the house was then used to accommodate prisoners of war. It was left in a very poor condition, the lead having been stolen from the roof, with consequent water damage to the interior, and handed back to the family who sold it in 1951.

Subsequently, two further owners have invested considerably in the building in order to maintain it for the future, but the farmland and property in the village remain in the ownership of the Wollaston family.

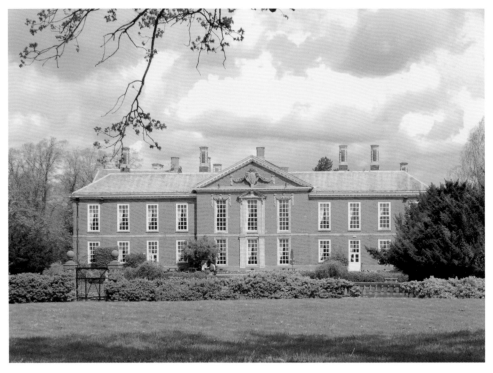

Market Bosworth Hall, photographed in May 2012 and now prospering as a hotel.

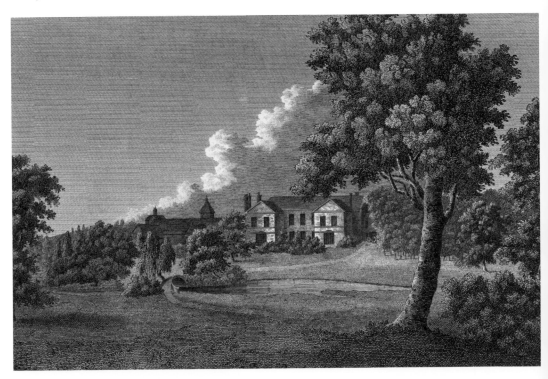

Shenton Hall, engraved by James Basire.

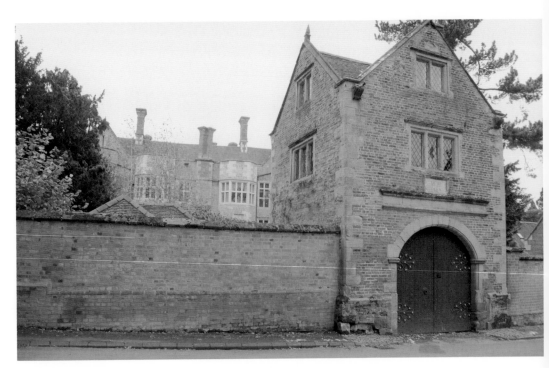

Shenton Hall. The gatehouse with the hall in the background in October 2014.

Acknowledgements

The author wishes to thank the many historians, geographers, parish clerks, innkeepers and church communities who have assisted him in compiling this book. I am most grateful for their positive, friendly and helpful responses, 200 years or more after John Nichols made similar approaches to their predecessors.

I must also thank Professor Roey Sweet, Professor of Urban History in the School of History at the University of Leicester who read the introductory chapter, Julian Pooley of the Nichols Archive Project, and Caroline Wessel of the Leicestershire Architectural and Archaeological Society who provided much encouragement while she was editing her own book, which has now been published.

My wife, Linda, accompanied me on several excursions, specifically to locations in Framland and Sparkenhoe, providing navigation and noticing dates and other details on monuments that I had missed. Linda also provided several of the colour images.

Bibliography

General

Bateson, Mary (ed.), *Records of the Borough of* Leicester, Vol II (London: C. J. Clay, 1901).

Billson, Charles James, *Medieval Leicester* (Leicester: Edgar Backus, 1920).

Blake, Peter Ackroyd (London: Vintage, 1996).

Brandwood, Geoffrey, Nikolaus Pevsner and Elizabeth Williamson, *Leicestershire and Rutland (in The Buildings of England)* (London: Penguin Books, 1960, and Harmondsworth, 1984).

Burton, William, *The Description of Leicestershire*, London (London: W. Whittingham, 2nd edition, 1771).

Cruttwell, Revd Clement, *Tours through the whole island of Great Britain* (London: Lackington Allen, 1806).

Cossons, Arthur, *The Turnpike Roads of Leicestershire and Rutland* (Leicester: Kairos Press, 2003).

Flower, John, *Views of Ancient Buildings in the Town and County of Leicester* (Leicester: John Flower, 1826).

Hoskins, W. G., *The Heritage of Leicestershire* (Leicester: Edgar Backus and the City of Leicester Publicity Department, 1946).

McKinley, R. A. (ed.), *Victoria County History, Leicester, Vol IV, The City of Leicester* (London: Oxford University Press for the University of London Institute of Historical Research, 1958).

Nichols, John, *The History and Antiquities of the County of Leicester* (London: John Nichols, 1795–1815).

North, Thomas, *The Church Bells of Leicestershire, Their Inscriptions, Traditions, and Peculiar Uses; with chapters on bells and the Leicester bell founders* (Leicester: Samuel Clark, 1876).

Skillington, S. H., *A History of Leicester* (Leicester: Edgar Backus, 1923).

Throsby, John, *The History and Antiquities of the Ancient Town of Leicester* (Leicester: 1791).

Wessel, Caroline, *A History of the High Sheriffs in Leicestershire* (Leicester: Caroline Wessel, 2000).

Wood Michael, *The Story of England* (London: Viking, 2010), pp 12–13.

Journals

Chambers, Alex, 'Memoir of John Nichols Esq. FSA', *The Gentleman's Magazine*, (December 1826).

Creighton, Oliver, 'Early Leicestershire Castles: Archaeology and Landscape History', *Leicestershire Archaeological and Historical Society*, 71 (1997).

Pooley, Julian, 'The Nichols Archive Project and its Value for the Leicester Historian', *Leicestershire Archaeological and Historical Society*, 75 (2001).
Rutland, Robert A., 'Leicestershire Archaeology to 1849: The Development of Chronological Interpretation', *The Leicestershire Archaeological and Historical Society*, 65 (1991).
Sweet, Rosemary, 'John Nichols and his Circle', *Leicestershire Archaeological and Historical Society*, 74 (2000), 1–20.

Ashby Folville (and Woodford family in Leicestershire)

Clark, Linda (ed.), 'Image, Gentry and Identity: The Woodford Experience, Jon Denton, in The Fifteenth Century (Vol V): Of Mice and Men: Image, Belief and Regulation in Late Medieval England', (Boydell and Brewer, 2005).

Brentingby and Wyfordby

Cotton Claudius XIII, 'The Cartulary of John Woodford of Ashby Folville' (B. L. MS).
Hughes, S. R. and P. Liddle, 'St Mary's Chapel, Brentingby – excavations and observations', *Leicestershire Archaeological and Historical Society*, (LIV).
Jarvis, Wayne, 'Wyfordby – Continuity and Shifting Settlement', (University of Leicester Archaeological Services, 2003).

Burton Lazars

McWhirr, Dr Alan, 'Exploring Leicestershire's Churchyards (Part 1)', *Leicestershire Historian* (July 2003), p 14.

Burton Overy

Stephens, Joan (ed.), *Aspects of Burton Overy*, (Market Harborough, Burton Overy Millenium Group/Troubador Publishing Ltd, 2000).

Cossington (Rectory)

Herbert, Anthony, 'Cossington Rectory', ARIBA, *Leicestershire Archaeological and Historical Society*, 19, (1937).

Frolesworth

Farnham, George F. and Alan Herbert, 'Frolesworth: The Church and Notes of the Descent of the Manor', *The Leicestershire Archaeological and Historical Society*, 12: Part 2 (1923).

Leicester

Bourne, Jill, 'William Wyggeston and his World', (Wyggeston's Hospital, 2013).
Thompson, A. Hamilton, 'Notes on the Buildings Visited on the Annual Excursions of 1915 and 1916', 11 (1920), 157–92.

Skillington, Florence E., 'Trinity Hospital Leicester', *Leicestershire Archaeological and Historical Society*, 49 (1973/74).

Thompson, A. Hamilton, *The History of the Hospital and the New College of the Annunciation of St Mary in the Newarke* (Leicester: Edgar Backus/ Leicestershire Archaeological and Historical Society , Leicester, 1937).

Leicester Castle

Thompson, James, *An Account of Leicester Castle* (Leicester: Crossley and Clarke, 1859).

Scalford

Farmer, David Hugh (ed.), *Oxford Dictionary of Saints, Fifth Edition* (Oxford University Press, 2011).

Somerby

Wilson, Alec, '*I Played the Piano and Made the Tea*' (The Parachute Regiment Afghan Trust, 2013).

Stapleford

Green, Emily, 'Bob Payton's Obituary', *The Independent* (Friday 15 July, 1994).

Stretton Magna

Hoskins, W. G., 'Seven Deserted Village Sites in Leicestershire', *Leicestershire Archaeological and Historical Society*, XXXII, 42/3.

Ulverscroft

Keay, William and Margaret, 'Ulverscroft Priory', *Royal Institute of British Architects* and *Leicestershire Archaeological and Historical Society* , 18, (1933), 87–93.

Withcote

Brandwood , G. K., *Withcote Chapel, Leicestershire* (Redundant Churches Fund, 1993).

Trollope, Andrew, 'An Inventory of The Church Plate Of Leicestershire, With Some Account Of The Donors', (Leicester: Clarke and Hodgson, 1890).

Woodforde, Revd Dr Christopher, 'The Painted Glass in Withcote Church', *The Burlington Magazine* (July 1939), 17–22.

Wymondham

Penniston Taylor, Ralph, *A History of Wymondham, Leicestershire, Second Edition* (Witmeha Press 2004).